For Janet,

It's a Fine Line

B. Johnson
10/25/03

It's a Fine Line

THE ART OF BRUCE JOHNSON

Bruce Johnson

Foreword by Dr. Lori Verderame

STACKPOLE
BOOKS

To my mother, who dragged me off to art school;
Jim Musselman, who inspired me;
and my wife Donna and son Dane, who were always, always there

Copyright © 2003 by Stackpole Books

Published by
STACKPOLE BOOKS
5067 Ritter Road
Mechanicsburg, PA 17055
www.stackpolebooks.com

Printed in China

10 9 8 7 6 5 4 3 2 1

First edition

A signed and numbered limited edition of this book has been published simultaneously.

Library of Congress Cataloging-in-Publication Data

Johnson, Bruce, 1944–
 It's a fine line : the art of Bruce Johnson / Bruce Johnson;
foreword by Lori Verderame.—1st ed.
 p. cm.
 ISBN 0-8117-2734-3; limited edition ISBN 0-8117-0069-0
 1. Johnson, Bruce, 1944– —Catalogs. I. Title.
 NC139.J592A4 2003
 741.973—dc21

2002014407

Foreword

by Dr. Lori Verderame

As an art historian and author, I could have taken this opportunity to offer the introductory words to a book about the art of Bruce Johnson as a chance to discuss the artist's talent, background, and impact on the art world. This foreword could have been constructed based on my reflections as curator of the Bruce Johnson retrospective exhibition hosted by the Susquehanna Art Museum in 2002. But Johnson's art is not only about an artist whose work is highly regarded and appropriately categorized within the context of late-twentieth-century American art. There is more to these works than the context, the history, the images. Johnson's work is about vitality and art as it reflects life.

Bruce Johnson pursued art from a young age; as a student at the Philadelphia College of Art he studied with a number of the most influential American artists of the twentieth century, including Will Barnet, Edna Andrade, and Boris Drucker. He forged an impressive path in the contemporary art world with both his beautiful watercolor paintings and his internationally recognized "Statements." Like other popular American artists of the last quarter century, Johnson enjoyed the prospect of sharing his work with others and bringing art to communities. It was his desire to "bring art to the man in the street" that led Johnson to create his beloved "Statements."

Many artists active in the late 1900s shared this community interest with Johnson, who made imagery within the cultural fabric of American society. Like Johnson, internationally renowned graffiti artist Keith Haring was trained as a commercial artist and worked to bring fine art out of the elite gallery system and offer it to the Everyman. Haring painted familiar images of radiating babies and barking dogs on subway cars and urban walls to spread his message of tolerance. Artist Kenny Scharf used familiar comic books and cartoon images for inspiration, uniting grand landscapes with depictions of animated TV characters such as Wilma Flintstone and Judy Jetson. Many viewers could find themselves in the work of artists like Haring, Scharf, and Johnson, making their work highly sought-after and collected. While the artists of the late twentieth century made art with both serious and silly messages, their imagery at its core consistently spoke to a diverse public.

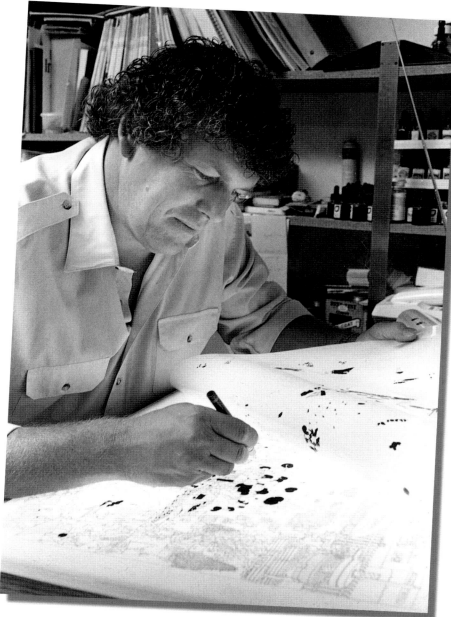

Bruce at work on color overlays for the reproduction of a drawing.

Acquired by public and private collectors worldwide, Bruce Johnson's quick-witted, enticing, and bold "Statements" are based on issues ranging from the simplistic to the socially aware. Comedy is ever present in works such as "1st Day in the Wilderness" (1976), "Weekend Get-a-Way" (1994), and my personal favorite "Brush Fire" (1993). Johnson takes on social issues such as suburban sprawl in "The Last Straw" (1983) and the degradation of the environment in "Buy Recycled" (1992). And of course he considers those unique occasions that speak to the collective human condition and unite us all: "A.C. 74" (1974), "Skiing?" (1984), and "AHHHHHHHHHHHHHHHH" (1996). In their communicative and artistic qualities, Johnson's "Statements" are nothing short of fantastic.

Along with his innate talent, Johnson derives his success from his keen understanding of the basic tenets of art. He remains committed to the rule that art is about communicating an idea. And, most importantly, he remembers that art is about joy. Through the "Statements," it is obvious that Johnson puts into practice the words of his famous teacher and *New Yorker* cartoonist Boris Drucker: "During a long career in art, there have been good years and bad years, but when I'm drawing, there has never been a boring afternoon."

Like Drucker, Bruce Johnson loves to make art. As a result, readers of this book will come to know Bruce Johnson for his captivating artwork and for his zest for life, which he makes available to us all in his "Statements."

How It All Began

I HAD MY FIRST ART LESSON WHEN I WAS ABOUT NINE OR TEN, WHEN MY mother started taking painting classes with Walter Baum at the Baum Art School, near our home in Allentown, Pennsylvania. Rather than find a baby-sitter she decided to enroll me in a class, too, and take me along. I remember a few things quite clearly about the experience. I remember being shorter than the art supply cabinet, which was one of my favorite things in the whole school (to this day, I am entranced by art supplies and art supply shops, although most of them have now been replaced by art supply catalog companies). I can also remember looking up at Mr. Baum, who always wore a white smock while he worked, and examining his oil paintings, impressionistic scenes of Bucks or Lehigh County, which I realized as I grew older were very valuable and collectible pieces of art.

In 1959, when I was in tenth grade, I took another art class, this time with Jim Musselman, an art teacher at my high school. The first session of that class was one of the scariest days of my life—equal to the first day of college, the first day of basic training, or the first day of a new job. During that class, Mr. Musselman asked us to draw a bow from memory. He gave me a huge blank piece of paper and he wanted me to get that paper dirty. I had no idea where to begin, but by the end of that school year I knew I wanted to be a professional artist. That's how influential Mr. Musselman was. He made me work hard, but I loved it. I even went to his classroom early in the morning before my other classes began and after school to work on my assignments. I was one of his more than 2,500 students that went into art as a career.

Later in life when I taught art classes I used the "huge empty paper" assignment to show my students that you had to begin a drawing some-where, and even though those first few pencil lines will probably be wrong, you need them to build on and change and eventually you will have something that looks and feels right. Several years ago, I was telling Mr. Musselman how clearly I remembered his class and how I used my experiences there to teach my own students. A few days later I received a package from him—it contained the drawing of the bow I did that first day of class. He had kept it for some forty years. And what I remembered as a huge piece of paper was only eight-and-half by eleven.

As a kid, I was always building models or drawing and painting school projects. That's me on the far left, sitting on one of my creations in Wildwood, New Jersey.

Between tenth and eleventh grades my family moved to the Philadelphia suburb of Plymouth Meeting. I attended Plymouth Whitemarsh High School, and I was devastated because the art classes there did not compare to those in Allentown. I kept in close contact with Jim Musselman, however, and he encouraged me to attend Saturday morning classes at the Philadelphia College of Art. During my junior and senior years, I took the Barren Hill bus to PCA every weekend and managed to prepare a portfolio that would get me into art college.

During my senior year, I was accepted at three art schools, but I chose PCA because I knew it, it was close, and it was the best of the three. My first year there I commuted because my father had converted an old pig barn near our home into a fantastic studio. The next three years, I lived in the city.

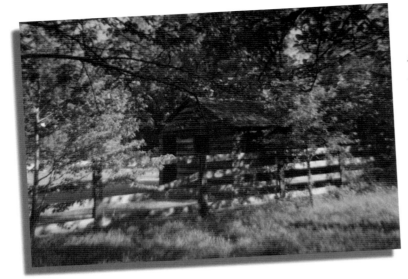

My first studio was a converted pig barn near our home in Plymouth Meeting. It's where I did my projects during my first year at the Philadelphia College of Art.

College was a wonderful experience for me; I was doing what I enjoyed most—being creative. PCA emphasized every aspect of art: I studied pottery, woodworking, printmaking, oil painting, architectural drawing, color and design, and more. I decided to major in advertising design because I wanted to make a living and because I liked the fast pace of the advertising classes and the planning that had to go into every advertising project. I also liked the variety of the assignments: one day I would be designing a newspaper ad, the next day a package for pills.

The faculty at PCA were outstanding. All the teachers were professionals in their own right, and they prepared us to work in the real world. (Too many art teachers, it seems to me, have never experienced anything other than teaching, and I think they lose sight of what's going on in the workaday world.) One of my classes was held on Wednesday evenings because the professor worked at the big advertising house N. W. Ayer during the day. Boris Drucker was one of my teachers; he was a freelance cartoonist whose work was appearing in *The New Yorker, Playboy*—all the best magazines. He drilled us and offered practical, useful criticism of our work. Award-winning illustrator Marvin Bileck taught calligraphy, and I began working with a pen. At the time, I didn't realize that years later I would pick up a pen again to begin the "Statements" now collected in this book. I also had the chance to study with Will Barnet, Edna Andrade, Jane Piper, and many other prominent artists. It was a fantastic opportunity for a young art student.

Every year, PCA would set up an exhibition of the work of the senior advertising design students and invite art directors from across the country to see it and arrange interviews. Before I graduated, I had job offers from three different advertising agencies and ad houses. I couldn't wait to start work as an advertising designer. But Uncle Sam had other ideas.

In 1965, during my junior year, I was drafted into the army, but I managed to get a deferment. The very day after my graduation from PCA, however, I was drafted again. Fortunately, I had taken a portfolio of my work to the U.S. Army Exhibit Unit in Washington during my senior year. They apparently liked what they saw because after basic training they sent me to Germany to serve as an army illustrator. I was there for three years and loved it. I did drawings for *Army in Europe* magazine, drew maps of Eastern Europe, even designed an underground briefing room. But the real joy was having the chance to see

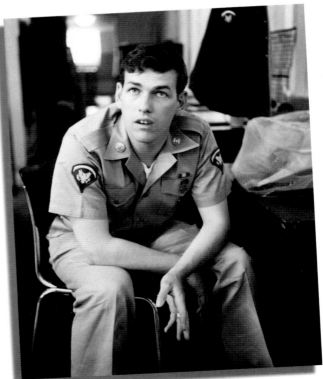

I married Donna and we had our son, Dane, while I was stationed in Heidelburg, Germany, where I did illustrations for the U.S. Army. (I know, I look kinda dorky.)

every part of the Old World. To this day, my wife, Donna, and I return as often as we can because we absolutely love the lifestyle, the old cities, the customs—and the food.

After my time in the military, I returned to Pennsylvania. My first job was designing on-air art, television guides, and promotional packages for WITF-TV in Hershey. Later, I worked with a small art agency called Krone Art in Harrisburg. It was during this time that I began to take weekend painting trips with The Seven Lively Artists, a diverse group of artists based in central Pennsylvania devoted to working outside instead of in the studio. I started using watercolors on these trips—a medium I was never taught how to use in college—and became infatuated with them. I've never stopped doing watercolors even as I worked more and more with pen and ink.

How did my pen and ink drawing all begin? As an art director, my job was to take lots of information and organize it in a way that was visually interesting—to make someone notice it, understand it, and remember it. Accomplishing this doesn't necessarily mean using big type and bright colors. It usually means beginning with a clever idea and using copy and graphics that clearly communicate that idea. One job might require the use of photographs to show off a product. Another might require an illustration or a three-dimensional piece of art to show things that a photo can't. So my job was to first decide what medium worked best to communicate a certain idea and then find the best way to use that medium. I used (and still use) the same thought process in my personal work. My original ideas dictate the medium I use to express those ideas.

Sometime in the early 1970s, during the Christmas season, I was wiring my son's electric train set. I remember that during this time a truckers' strike was causing the price of everything to go sky-high. I thought it was interesting that the actions of a relatively small group of people could affect such a large part of the population. I thought about how interconnected everything seemed to be. Like the train set, one little blip with the wiring and the whole system would lose its juice. It seemed to me that the world was so complex yet so fragile. I started thinking about how I could express this idea on paper.

In college, I had always used a crow-quill pen for my ink drawings because of the beautiful quality of the lines it creates. But for this new drawing, I decided to use a rapidograph pen, something I'd never used

One of the only "official" drawings I kept from my army days.

"High Point, Hershey." I started using watercolors when I joined The Seven Lively Artists on their plein air painting trips throughout the eastern part of the country.

before. The rapidograph would allow me to create a line that was consistent throughout the whole piece. I came up with "A.C. 74" (page 3), which showed half the world connected by a complicated tangle of wires that eventually all led to just one line plugged into a single outlet. Cut this line, and all the lights go out. I was pleased with the way the drawing turned out. It seemed to make exactly the statement I wanted to make, and it conveyed the idea in a humorous and memorable way. (Interestingly, several years after I made this drawing into a print, a massive blackout in New York City made headlines across the country. The print sold out soon thereafter.)

One early-winter morning while driving to work, I noticed a big traffic jam in the middle of a forest; it was the first day of hunting season. When I got home, I drew "1st Day in the Wilderness" (page 5), which showed a crowd of cars and hunters packed into a tiny group of trees. Again I used a rapidograph, and this time I added a bit of color—bright orange like a hunter's safety vest—which I thought made the whole drawing work.

I realized I had found a medium to express the ideas that would pop into my head. I discovered it was easier to convey the ideas with a drawing rather than with words; a written or spoken description about the absurdity of a bunch of hunters crammed into a bit of woods just

isn't all that funny or memorable. But a drawing has immediacy—people react instantly; they can relate to the situation and laugh. And I realized that an added attraction was all the details. They would hold the viewer's attention after the initial response had passed. I was pleased to see that sometimes I could hold the viewer's attention for a very long time.

Those very first "Statements" drawings had very little or no color. There were two reasons for this. First, I didn't think they needed lots of color. And second, I couldn't afford to print them in color.

In the mid-'70s, I took a job as executive art director for Armstrong World Industries. The job put me in touch with professional printers and printing houses. One day a visiting printer offered to print one of my drawings so that he could have a copy. Eventually, I had six drawings made into prints, and I was surprised to discover that people actually wanted to buy them. At the time a good friend of mine, George Logan, was showing his watercolors at various outdoor art shows. I decided to borrow his old racks and display my prints at a show. I couldn't believe the response. I think I made $400 in one weekend, selling only six different prints. And they weren't even framed (I couldn't afford it); I sold them out of boxes covered with pieces of glass to keep off the bugs and the rain.

That first show gave me a lot of encouragement. Even though I was gainfully employed, I decided to really work at selling my artwork in my spare time. I began doing more drawings and making more prints. I also created a small catalog of my prints—and this was where all my years of experience as an art director really paid off. I knew how to design effective promotional materials and ads and I knew how to prepare them for printing. After so much time designing materials to sell other people's products, I was now selling my own.

While still going to outdoor shows, I also went to galleries to try and sell my drawings, but for the most part they had no time for me and didn't seem to care for my work. I was disheartened, but I later realized that galleries have to maintain a certain image and attract a targeted clientele. They have to be concerned with their own survival and not necessarily yours. I realized *I* had to be concerned with my

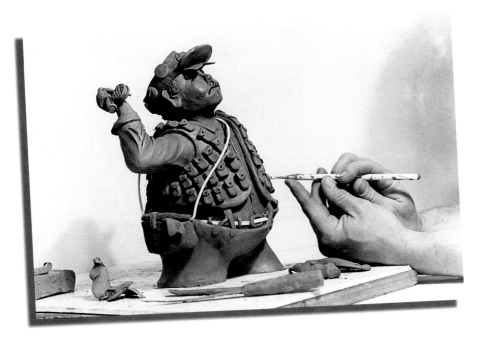

Sometimes a three-dimensional piece seems to be the right way to express an idea. Here I'm working on the clay sculpture for "It's All in the Wrist," which would then be cast in bronze.

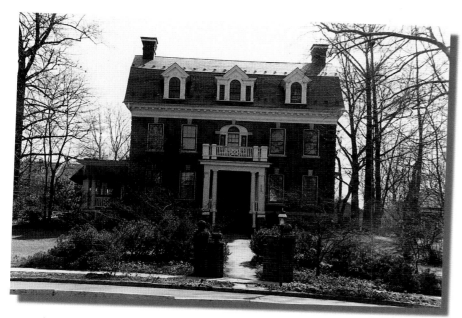

Our home on Main Street
in Annville. The framing business was in the basement, the first floor was a
gallery, we lived on the second floor, and the third floor was my studio.

Of course, selling through galleries is a lot easier. But most galleries usually take things only on consignment, so often the work gets stuck in a corner because the galleries have no personal investment in it. And if a piece *does* sell, the gallery takes as much as a fifty percent commission, which sometimes leaves little left for you. To me, selling through galleries just isn't as much fun as selling directly to customers. I've loaded and unloaded more van-fulls of artwork than I care to think about, but for me—and for many people I know in the business—the outdoor art show circuit is the best way to get started.

I continued to make new drawings and go to more and more art shows throughout the '70s. And I started getting requests from companies that wanted me to depict their factories or some fun aspect of their businesses. Soon I could afford to print my work in color. So I decided to make a big leap: my art director job was getting a little boring, and I really wanted to work on my own pieces all the time. So I left the security of a full-time job to go out on my own. And I thought that huge piece of paper in Mr. Musselman's class was scary . . .

survival, and so I decided to continue to create, produce, market, and sell my artwork all by myself. I'd put my own money into my work, and if it was successful, I'd profit; if it failed, I'd take the hit.

Doing outdoor art shows is hard work. You put in long hours setting things up and lugging things around and taking things down. You're constantly dealing with bad weather and have to worry about your work getting damaged or destroyed. But I highly recommend outdoor shows to any artist who wants exposure. They are an inexpensive and effective way to meet lots of people and get their reaction to your work. I've always had two highs as an artist: completing something I feel good about (it doesn't happen all the time) and seeing someone else appreciate it. Art shows give me a great chance to get almost instant feedback and see other people's reactions to the things I've created.

I've found that people get a big kick out of meeting an artist and very often buy a piece of art because they like the creator. Over the years, buyers start to become friends and you actually feel a little guilty about making them pay for your work. (On the other hand, I've heard people say they didn't buy a piece of art after meeting the artist because they "didn't like the guy.")

After a while, it seemed that our home became the gallery and the gallery became our home.

I've always kept in touch with my tenth-grade art teacher Jim Musselman, who joined me for the party celebrating the opening of Gallery 444 at Chimneys.

At the time, Donna, our son Dane, and I were living in the village of Mt. Gretna. But since we were running out of space there, and since the community was a bit too small and isolated to support an art gallery, we decided to move. We found a wonderful Georgian Revival house on Main Street in Annville—a place big enough for a studio, a gallery, and the framing business I took over from my framer, who wanted to retire. We opened Gallery 444 with a big show in 1979 (on March 28, the same day as the accident at Three Mile Island!) and settled into our new life.

Things got hectic pretty quickly. We kept busy in the frame shop, framing my pieces and the work of others; we eventually had to hire some help. The gallery required a lot of paperwork (something I never much liked), which cut into my drawing time considerably. So Donna decided to leave her teaching job of eleven years to manage the business. I continued to do more and more outdoor shows and create new "Statements" and other pieces, including watercolor scenes of the Pennsylvania countryside, which I would exhibit in the gallery.

As the years went by, it seemed the business was slowly taking over our personal lives. So we decided to build a separate gallery in Hershey, on a commercial stretch of East Chocolate Avenue, just past Hersheypark and the old chocolate factory. We named the building "Chimneys" and opened the new Gallery 444 in June 1988 with a show that featured watercolors from my recent trip to the former Soviet Union.

"Statements" were selling in more and more places. In addition to outdoor art shows, we started going to big trade shows in Los Angeles, New York, and Amsterdam that sold to galleries and wholesale buyers. My work was soon being shown and sold in more than 2,000 galleries in this country and in Europe, mainly in Germany and Switzerland. My work has been represented by several agents in Europe, most notably the Kunsthandlung Springmann gallery in Freiburg.

About a year after the new gallery in Hershey opened, I thought it would be worthwhile to offer some less expensive items. Darryl Eckert, a young entrepreneur who lived nearby, was involved with printing and marketing T-shirts. Making T-shirts seemed like a great idea. I chose six of my drawings that had very little color (since color was more diffi-

The grand opening of the Hershey gallery was a bigger and more exciting event than I ever imagined it could be.

"Going Home," Ireland. Trips abroad continue to inspire me. In recent years I've been captivated by the vivid greens of Ireland and the bright blues and whites of Greece.

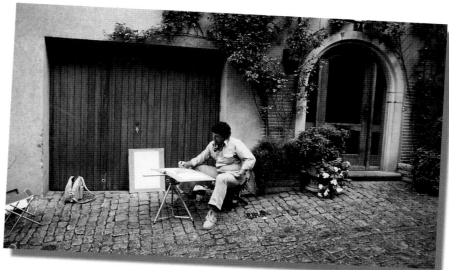

Working outside in Germany—on some trips to Europe I would trade paintings for lodging.

cult and expensive to print well), and we reproduced them on shirts. They were a hit. One gallery that sold my prints wanted to carry T-shirts for the Christmas season. We sold them $8,000 worth of shirts in four weeks.

The T-shirt thing kept getting bigger and bigger. I reproduced more drawings. We opened a kiosk at a local shopping mall, then three more. We licensed the work to others who set up kiosks and sold the shirts and other functional items: puzzles, notepads, mugs. We hired more employees—soon we had forty. We found a 4,000-square-foot warehouse for storage and shipping. We began selling to Wal-Mart and Kmart, which put in an order for 60,000 shirts . . . The whole thing began to get bigger than I ever imagined it would, and eventually we decided to sell the T-shirt business to a large printing firm that could handle the volume and take the risks we were leery of taking.

A few years ago, I decided to retire—and if retirement means continuing to draw and paint and travel and teach and exhibit, that's where I'm at now. The business part of being an artist is necessary, and I always wanted to be involved with every part of my business. But I've always struggled to find enough time to create new pieces when there were business matters at hand. I always wanted to find enough time for the creative process to fully develop. That's what I'm lucky enough to have now.

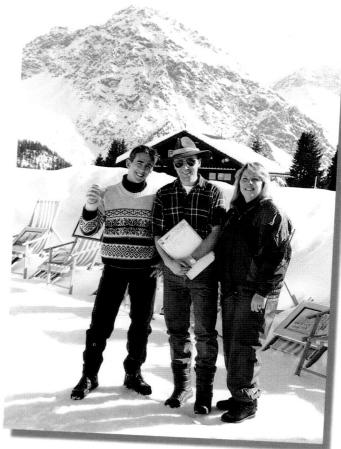

The most incredible show I've ever done was in the mountain resort village of Arosa, Switzerland. The gallery was small, so we moved the "Statements" outside and displayed them on chairs, at 6,000 feet above sea level. Skiers would stop on their way down the mountain, have some wine, buy a drawing, then continue on their merry way. It was a huge success. That's Dane on the left, Donna on the right, and my rep Hans Dappen in the middle.

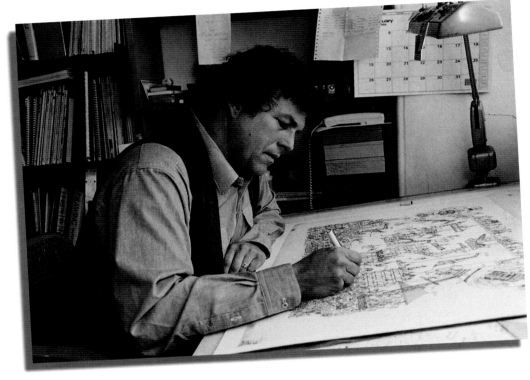

Putting a good idea down on paper is the most important part of the creative process. Good ideas get away quickly if you don't take the time to capture them.

I've always enjoyed the act of creating something new, something that never existed before, whether it's a drawing, a needlepoint kit, or sculpted bronze door-pulls. (And if you have the energy and courage, why not take the next step: developing advertising materials and marketing to others?) But to me, the process of doing the work is the most challenging and rewarding thing. In some ways, when a piece of art is completed, it's finished, and then it's time to move on to another challenge. When anyone asks me what my favorite piece is, I always tell them "the next one."

Ideas can come at any moment. Some are good and others after a while don't seem all that interesting. An idea comes from seeing someone do something, or hearing a word that conjures up an image, or simply being in the right place at the right time. To be honest, I've always found that getting ideas is the easy part. Putting them down on paper is what's tough. Making a thought a reality is where the work is. Just think about all the great ideas that get away because they aren't captured in paint or clay or on paper or some other way.

In Indonesia, in Bali in particular, they believe that creating things brings you closer to the Creator himself. Every person there is involved with some aspect of the arts. Music, sculpture, jewelry, painting—everybody creates something. I think that's wonderful. I believe it's important to leave something behind that is meaningful to prove you were here to begin with. It's a way of being immortal.

Bruce Johnson
Dingmans Ferry
August 2002

First Drawings

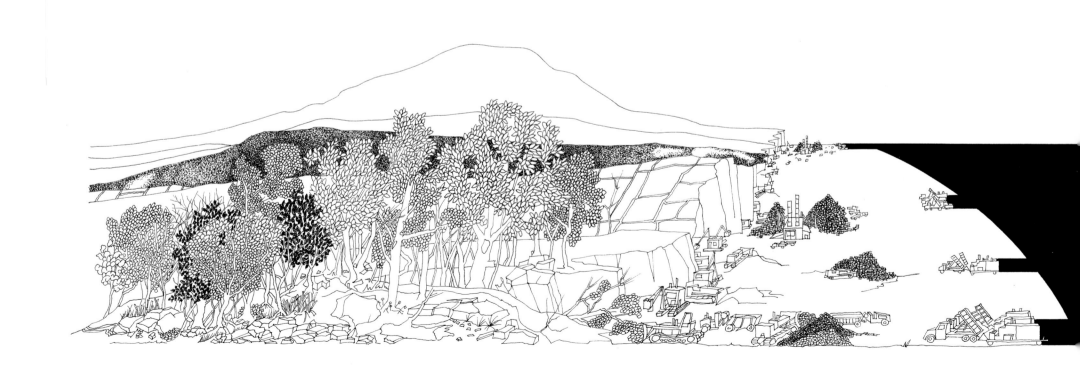

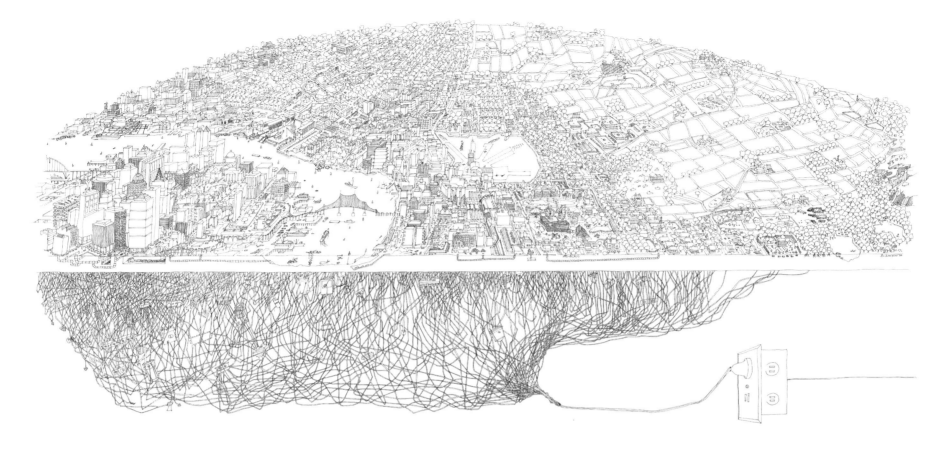

A.C. 74 (1974)

Progress (1976)

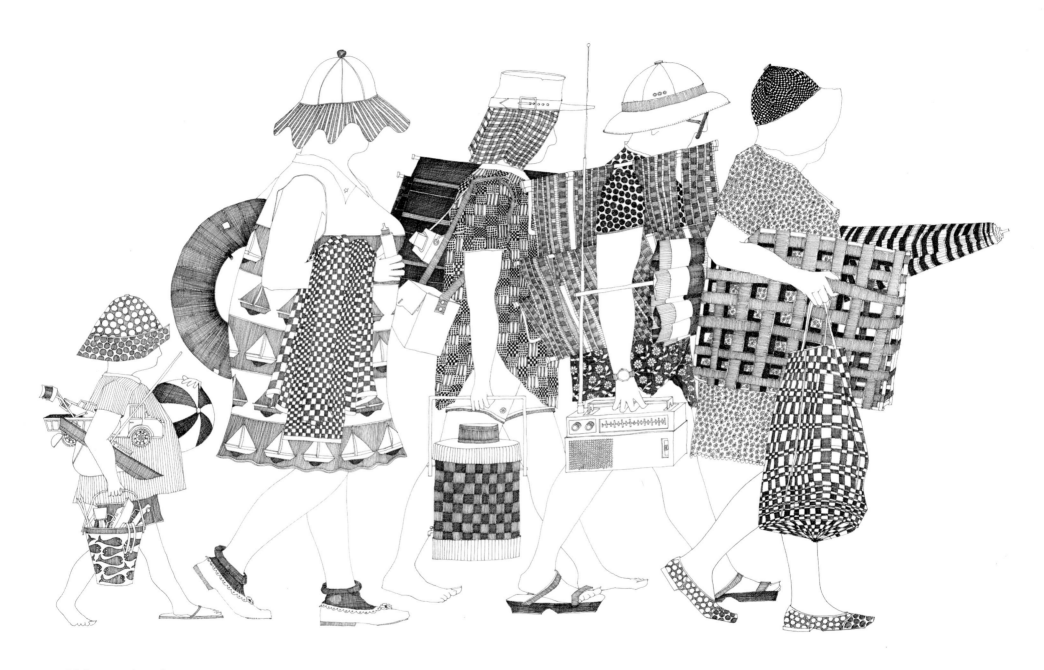

Did You Bring the Cups? (1976)

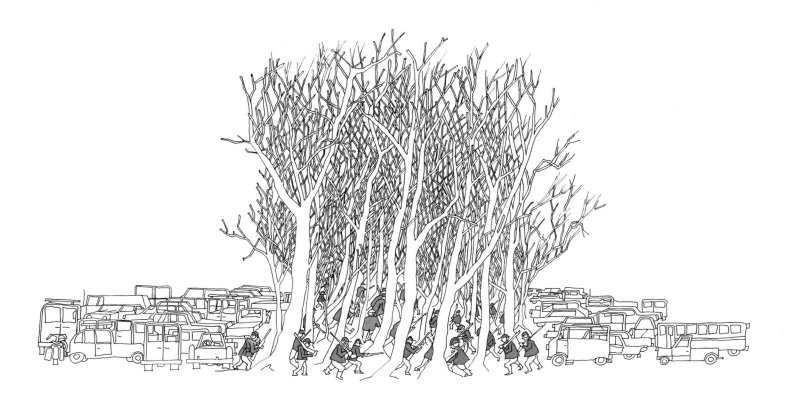

1st Day in the Wilderness (1976)

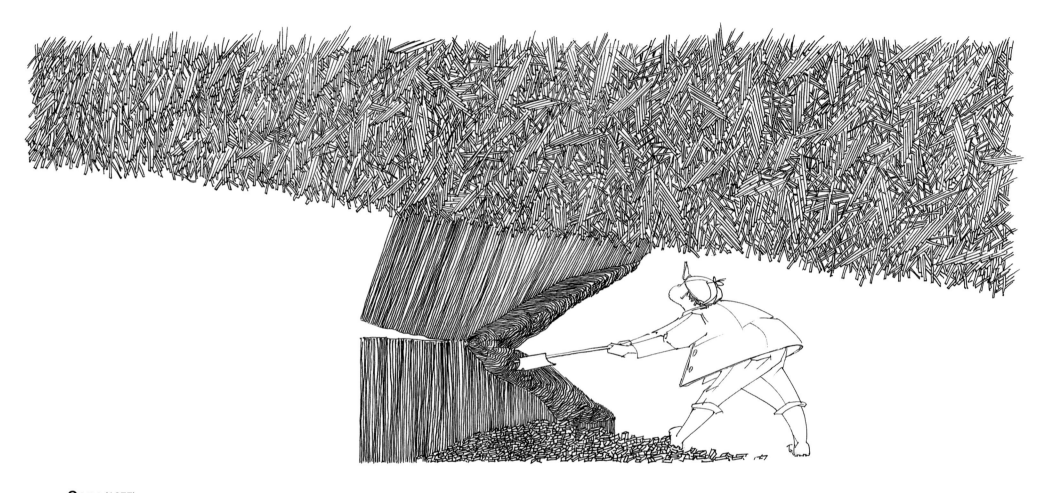

Oops (1977)

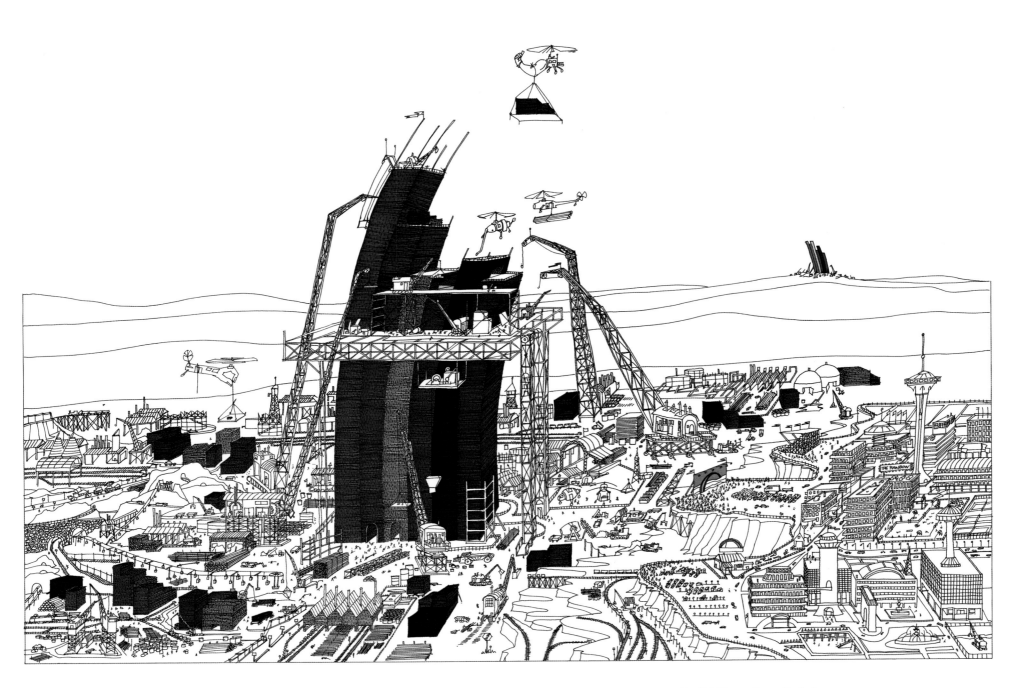

Build Your Own Rainbow (1981)

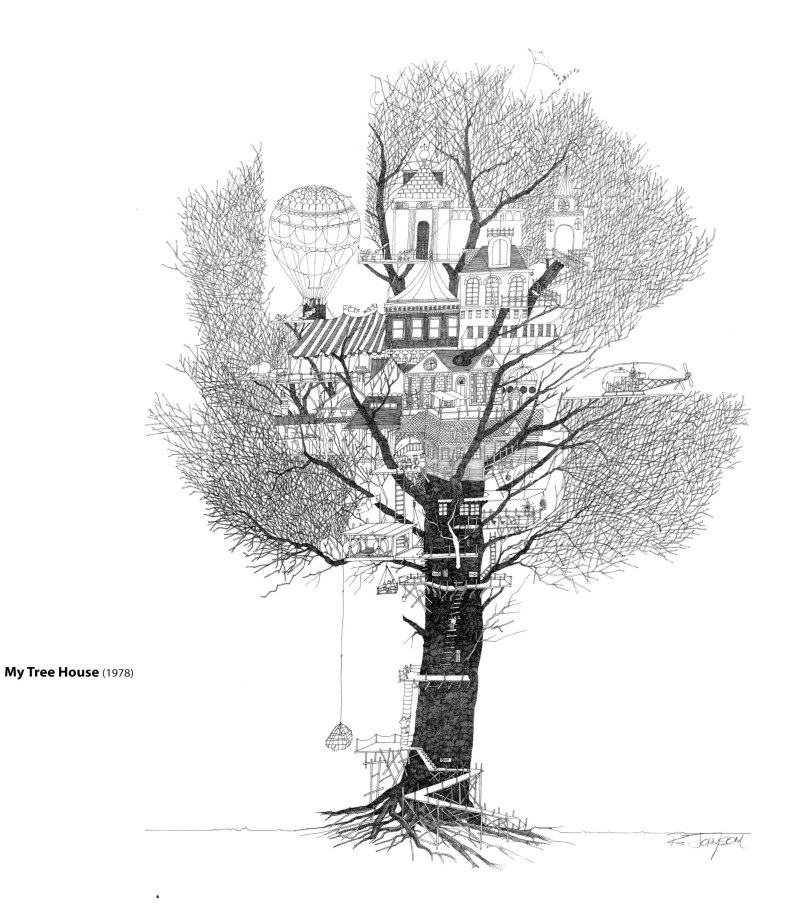

My Tree House (1978)

Urban Life

My life expectancy in a city is about three days. My plan usually is to go to a city, take advantage of it, then get out as quickly as I can.

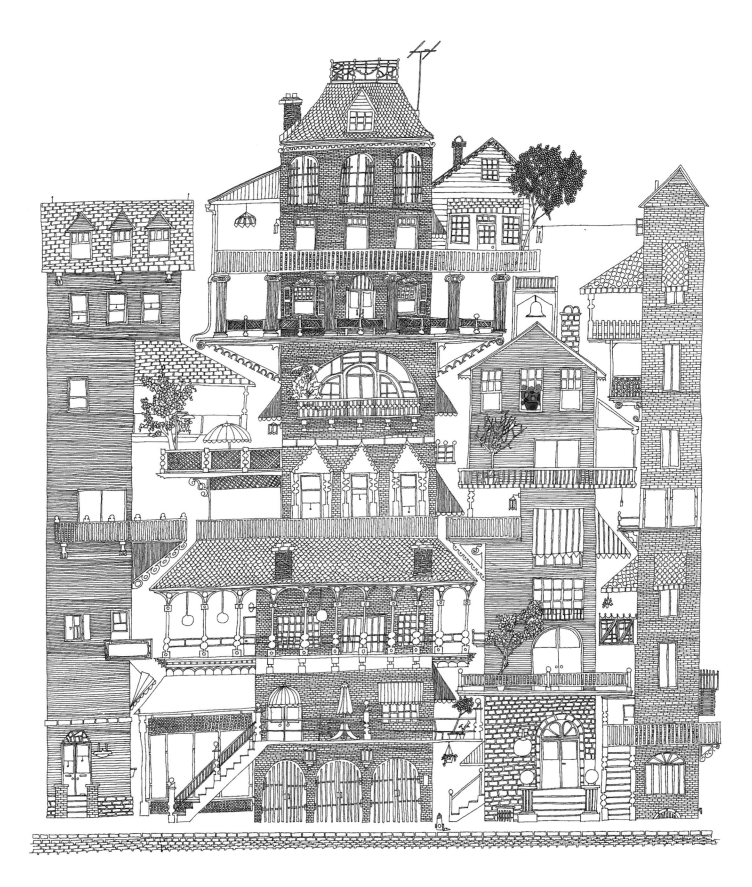

City Life (1981)

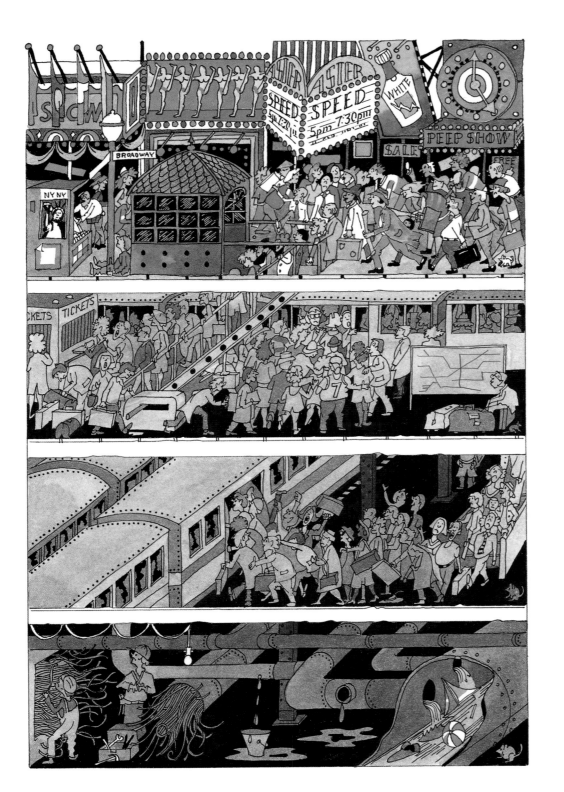

5 PM Friday (1996)

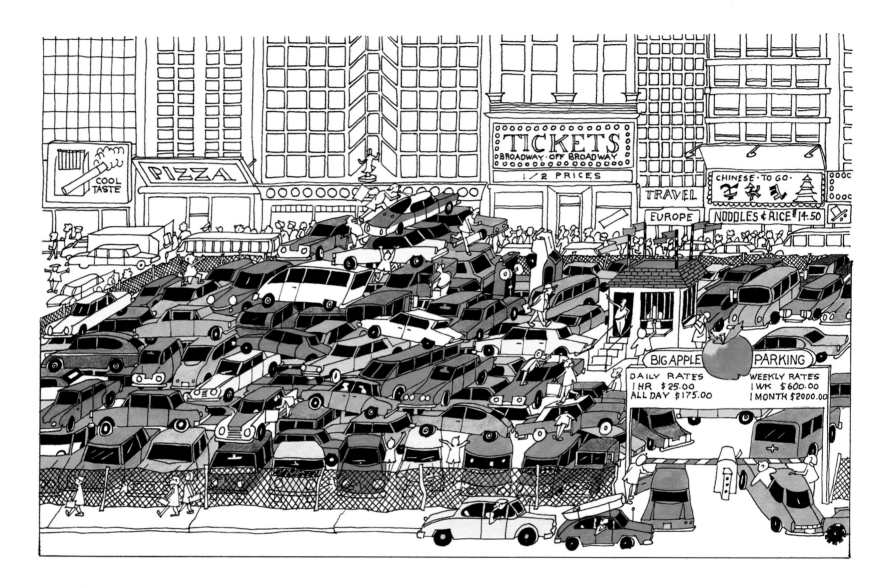

Central Park (1996)

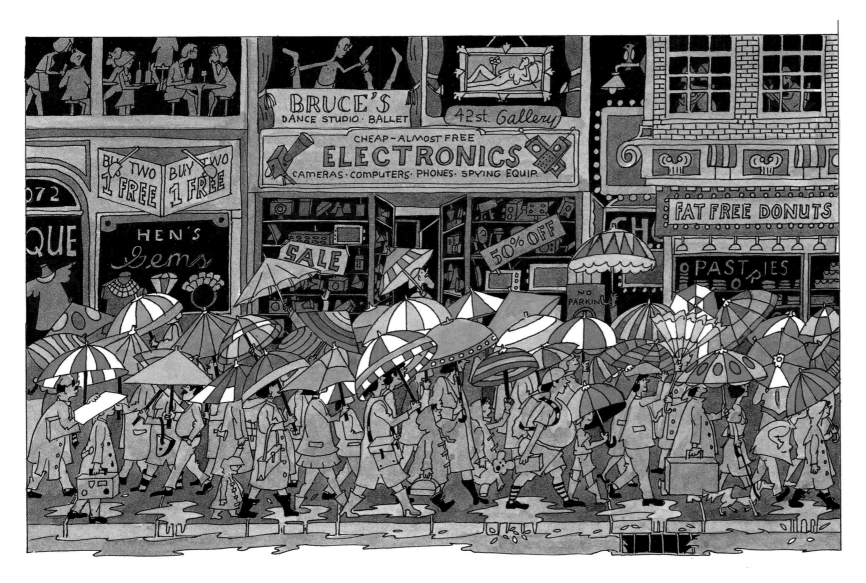

Urban Rainbow (1996)

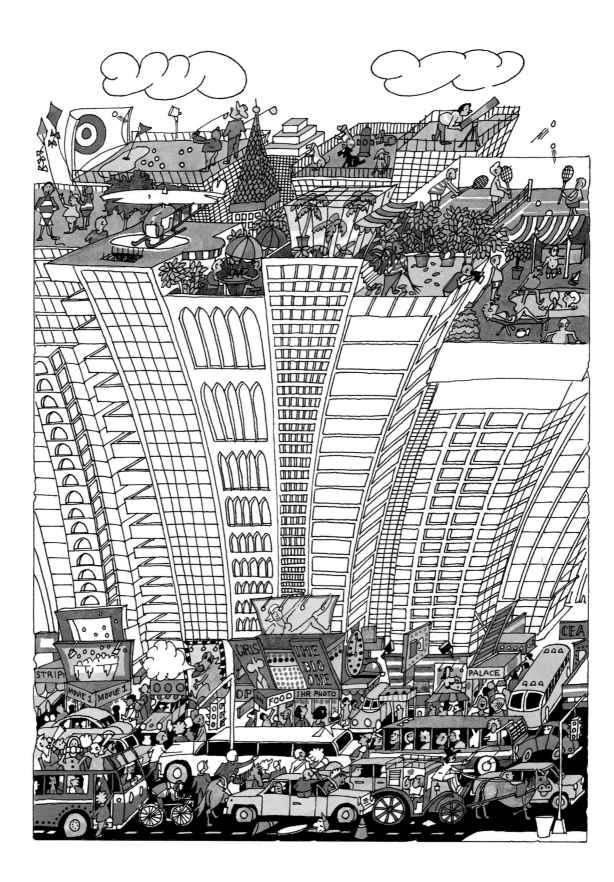

14

Uptown / Downtown (1996)

Sports

What do these drawings show? That people will do almost anything to entertain themselves—shoot a duck or catch a fish or try like crazy to get a ball into a hole. Imagine if all that time, money, and energy were directed toward something else: world hunger, let's say.

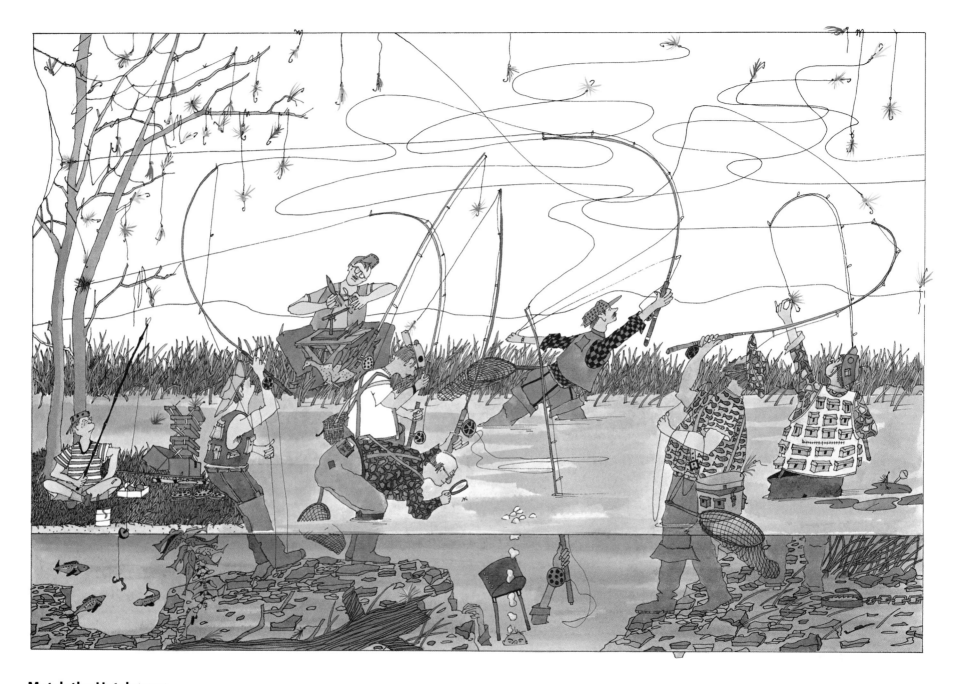

Match the Hatch (1985)

As a kid I would grab my pole and some worms and go catch fish. Not anymore. Now I have a tackle box so large I need a dinghy to put it in. I have several rods and reels, two boats and a canoe, and I even live on a lake, but I'm not sure I catch any more fish now than I did as a boy. Some anglers take it even further, using $2000 bamboo fly rods and wearing all the "proper" attire. They sure look good, but I bet the kid with the worms has more fun.

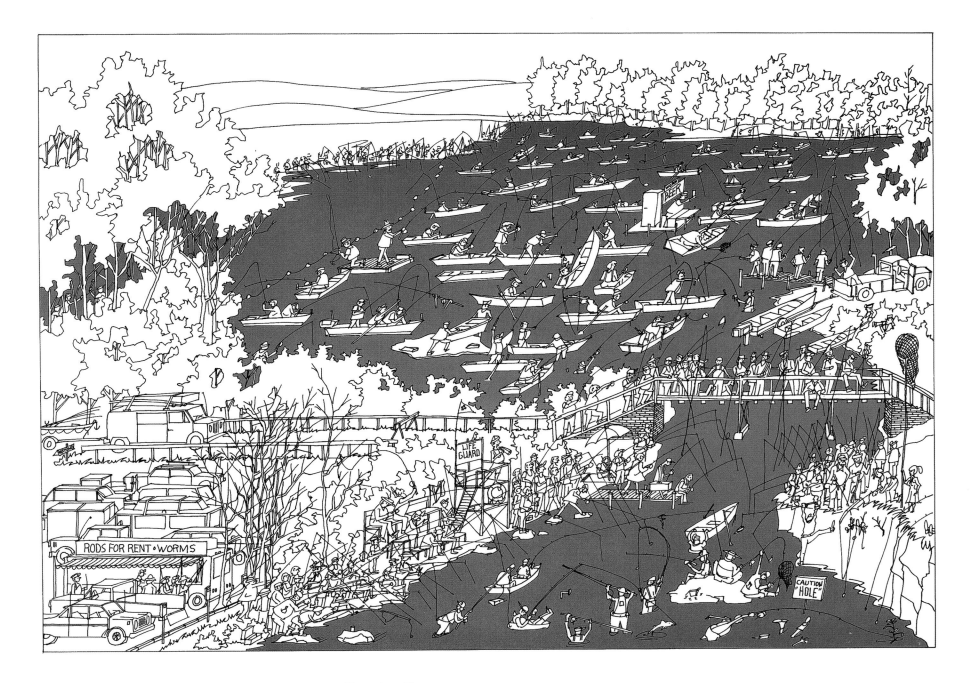

Opening Day (1984)

Guys will tell you that it's great to get away from all the hustle and bustle and spend a day in the forest or on the lake with Mother Nature. But did you ever notice that they all go on the first day of the season, and the forests and lakes are more crowded than Grand Central Station at rush hour? Mother Nature probably goes to the city on opening days. It's safer.

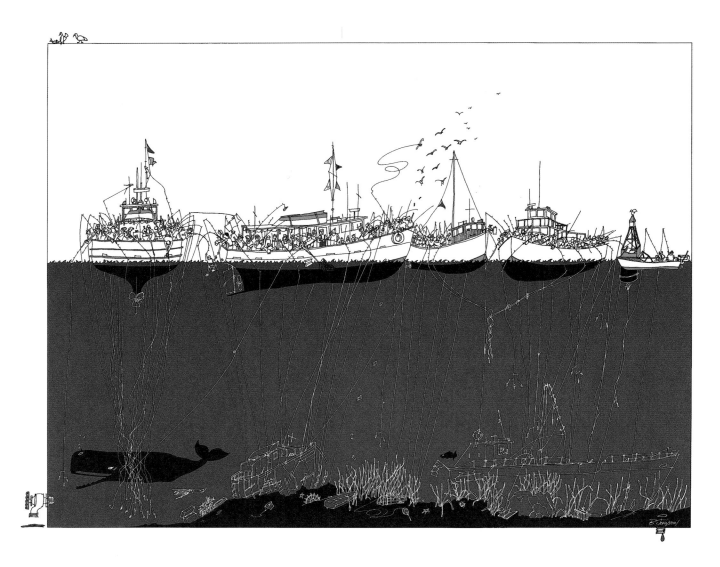

Party Boats (1990)

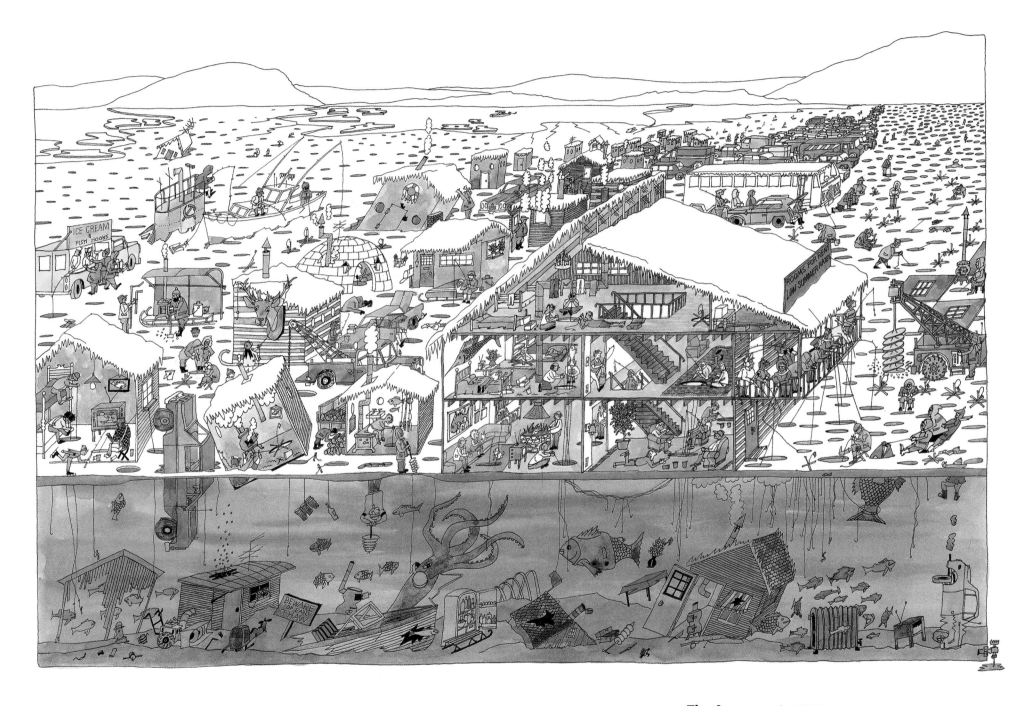

The Augernauts (1987)

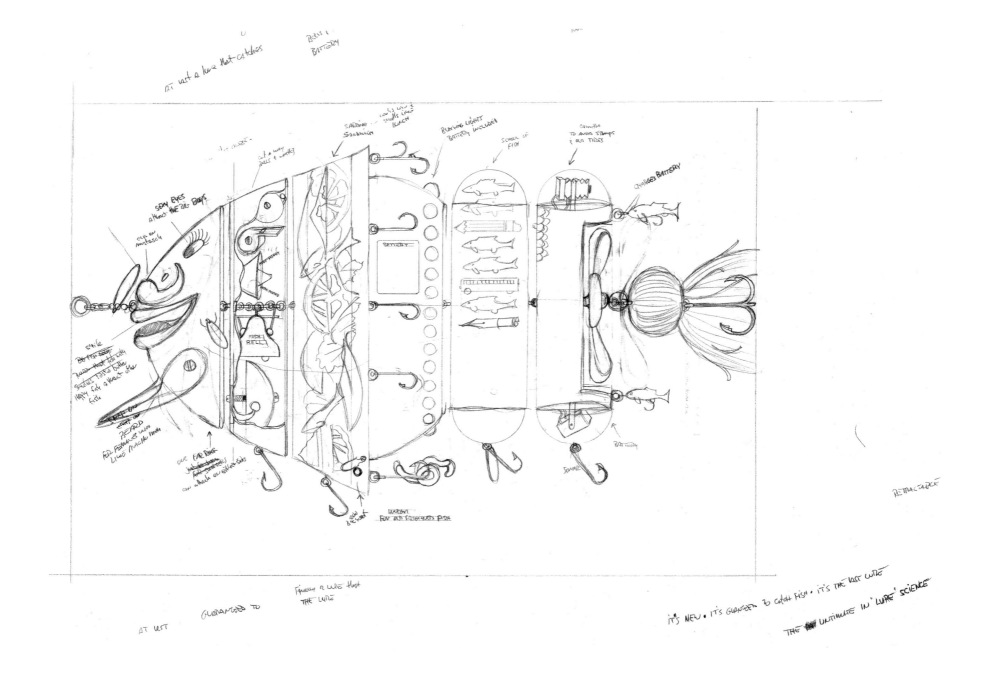

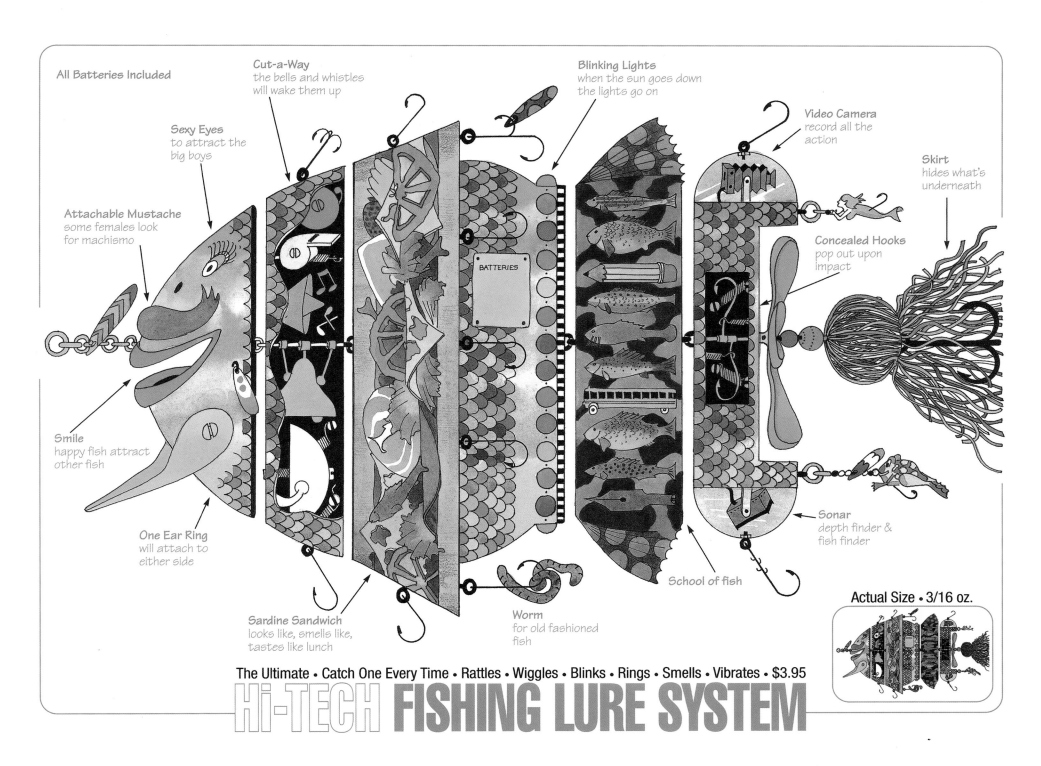

Hi-Tech Fishing Lure System (1996)
People design these fishing lures to totally confuse perfectly well-adjusted bass.

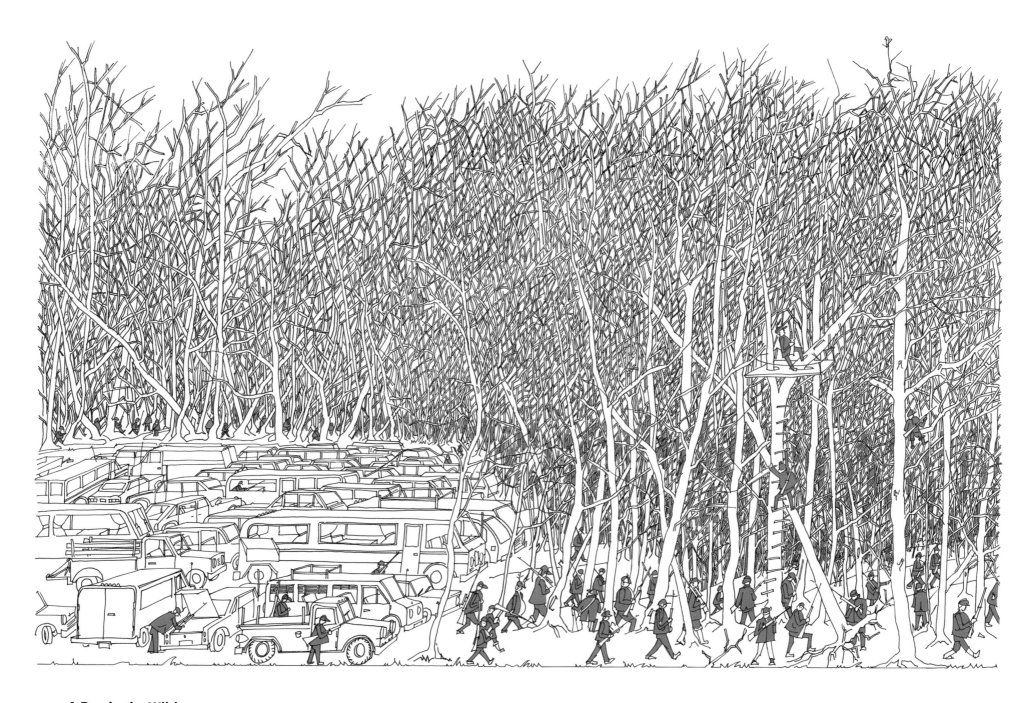

A Day in the Wilderness (1982)

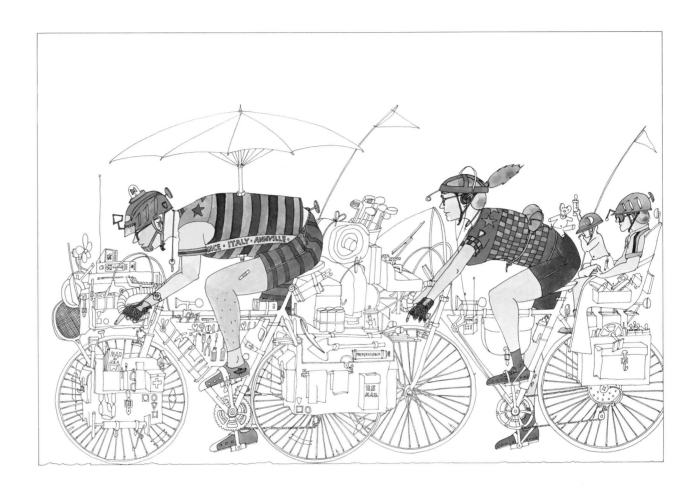

Bare Necessities (1983)

My pet peeve about sports is that they keep inventing all these new gadgets: gadgets to make things lighter, faster, brighter, duller, smaller, larger . . . gadgets to guarantee success. I love the cyclists who buy the lightest bike on the market and then attach thirty pounds of stuff to it.

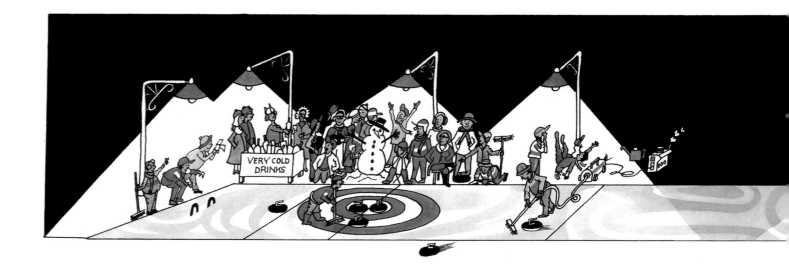

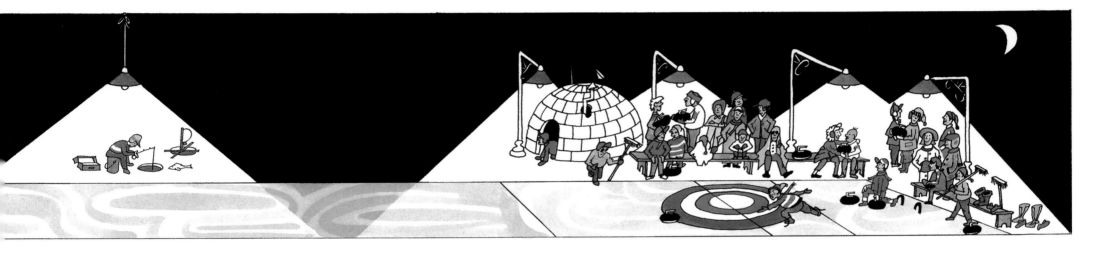

Curling (1997)

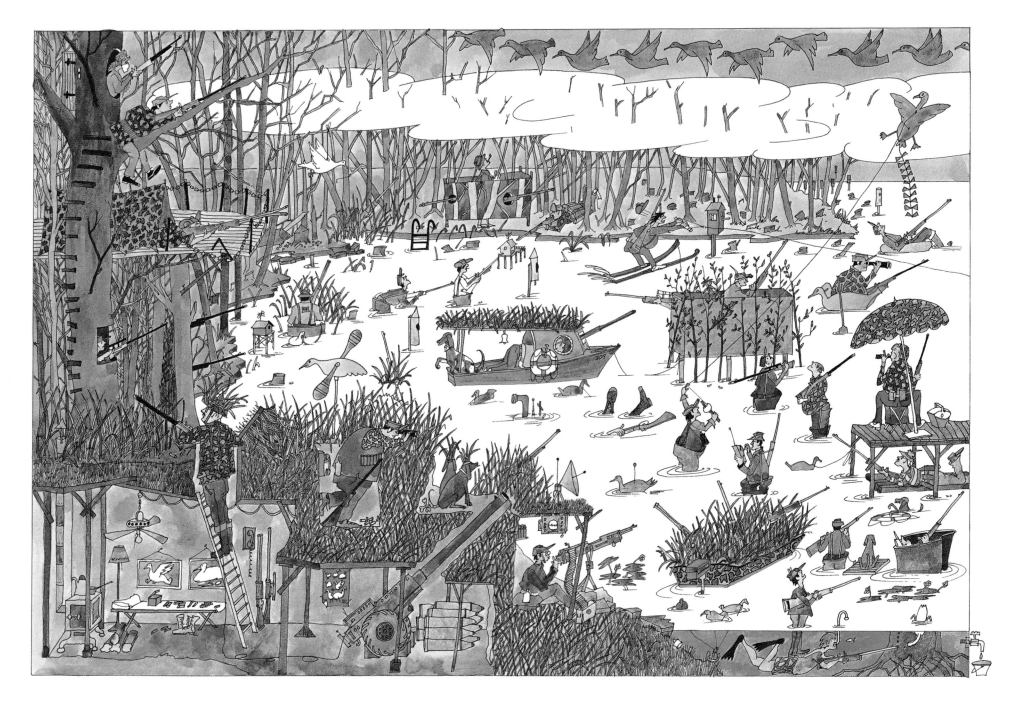

Basic Duck Hunting Techniques (1984)

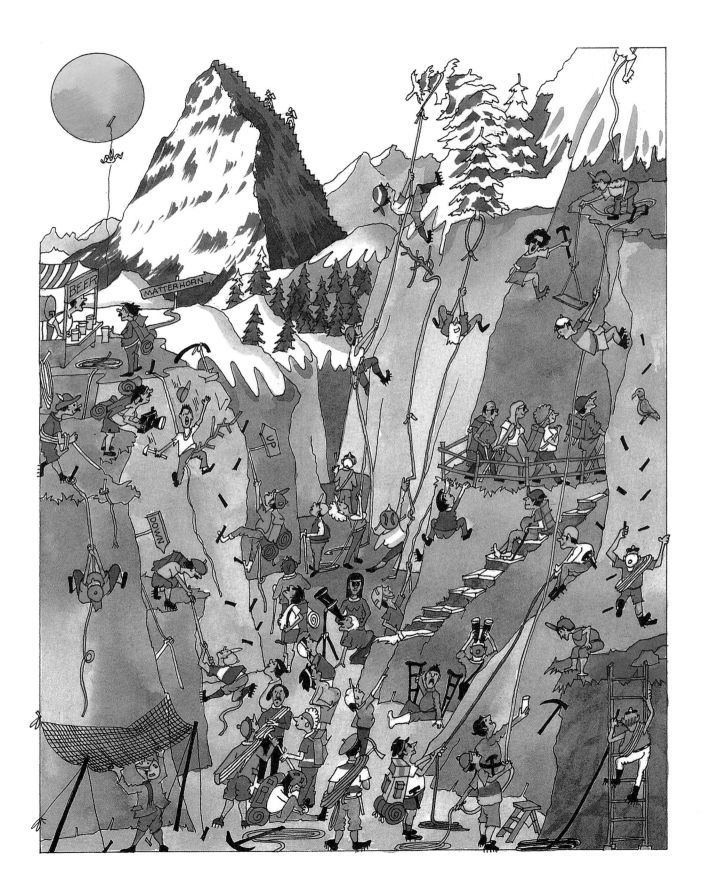

Easy to Moderate (1995)

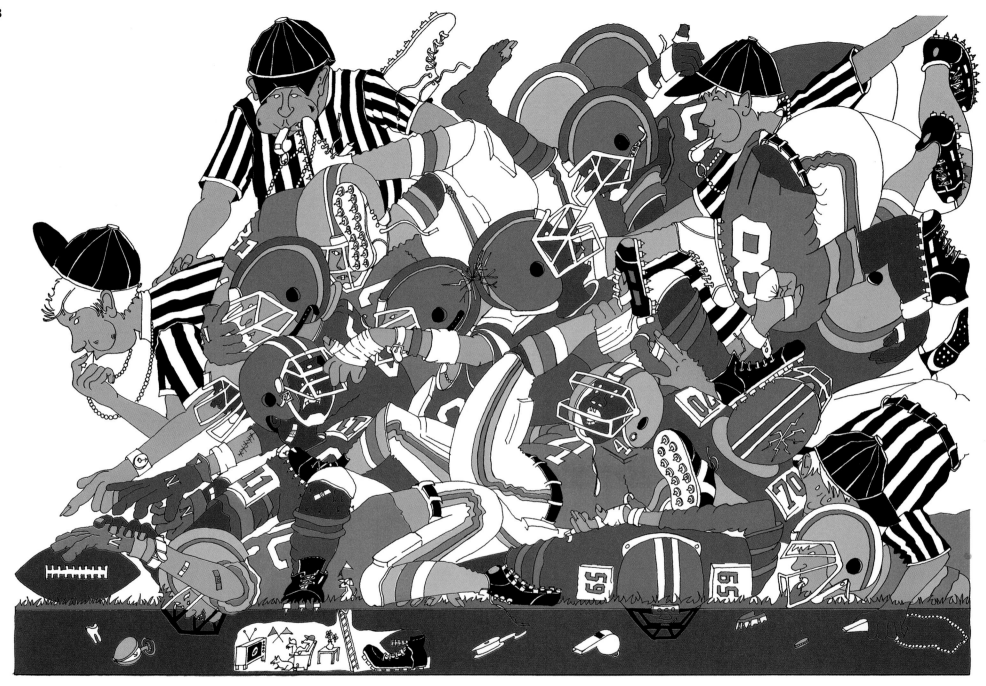

Fumble (1992)

The object of many sports is to carry a ball across a line or hit it into a hole or smack it over or into a net. Sort of silly, isn't it? It sometimes seems people actually risk their lives trying to get that ball where they want it to go and others don't want it to go. Was the ball invented before or after the wheel?

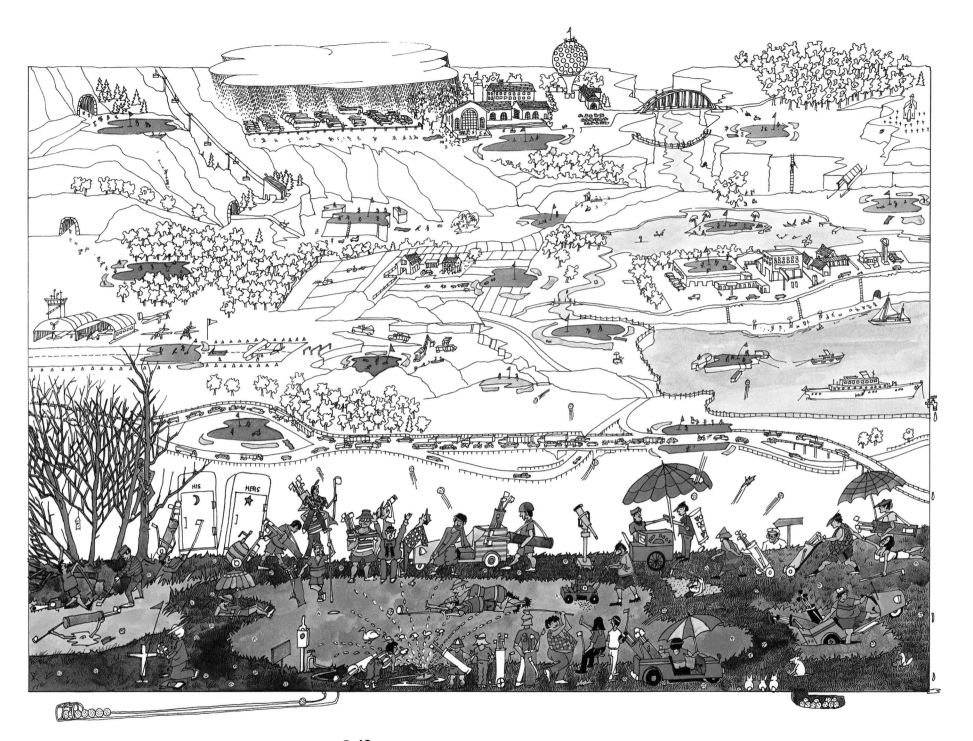

Golfing (1984)

Golf . . . I have to laugh. I've played golf about five times in the past forty years. Only once has a golfing partner ever asked me to go with him a second time. The word "handicap" suggests my ability.

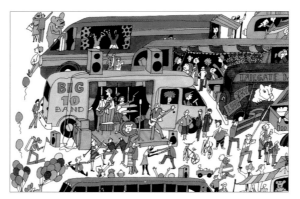

details from "Tailgating"

TAILGATING

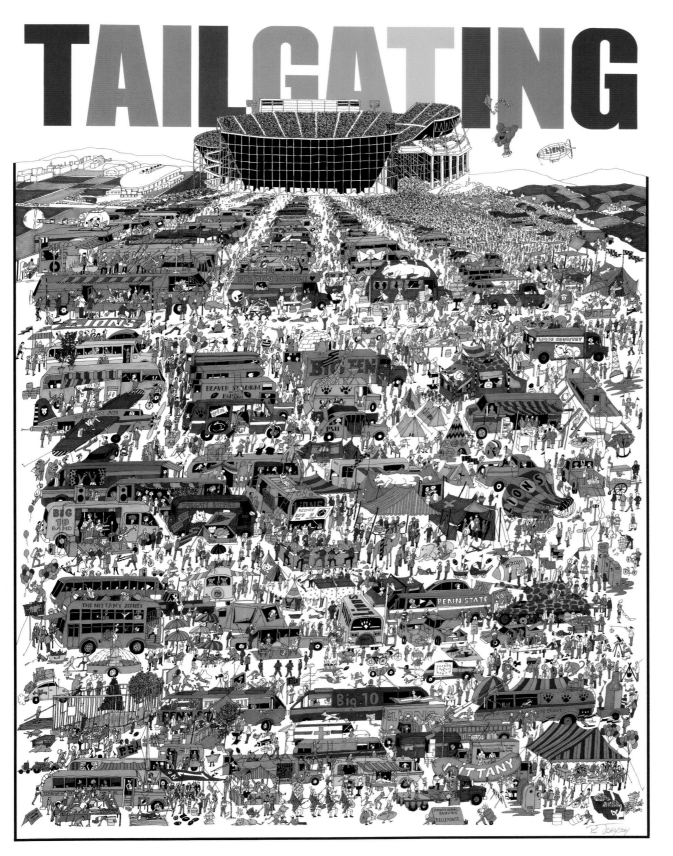

Tailgating (1990)
Tailgating is the party before the game. In fact, some people skip the game because of the party; they usually have to check the paper the next day to find out who won. I thought I had exaggerated a great deal in this drawing, but I found out that most everything I "invented" actually happened at one time or another.

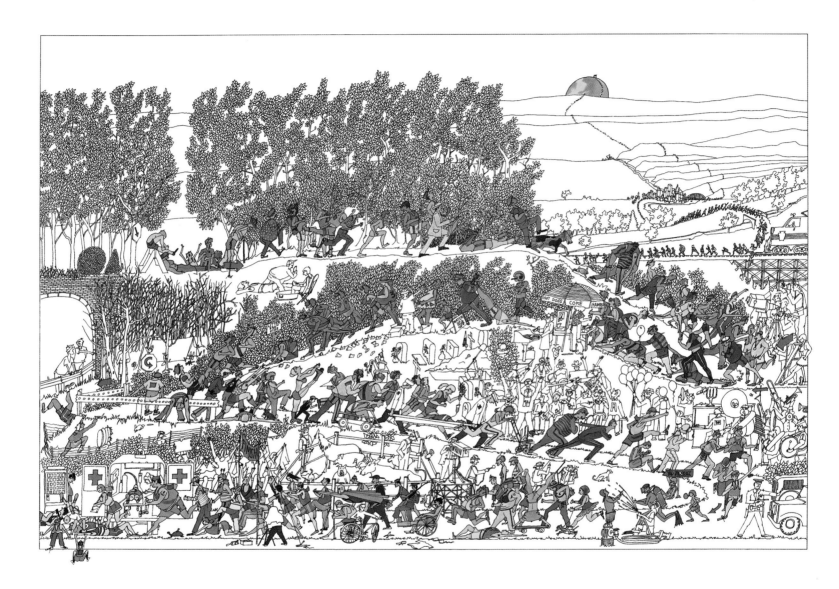

It's All Down Hill From Here (1983)

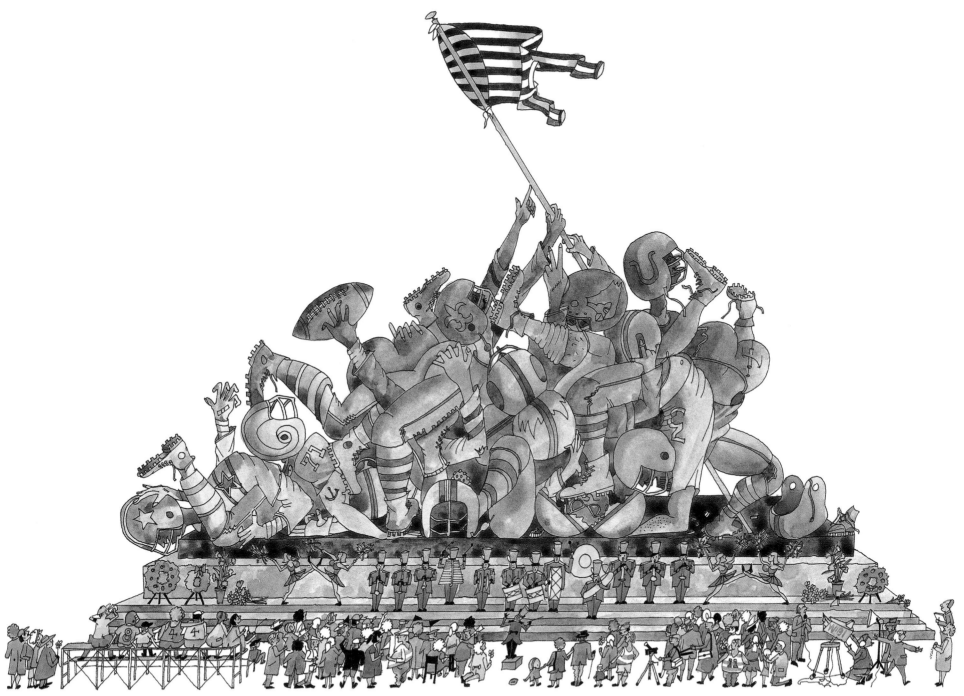

Memorial to Sunday Afternoons (1987)

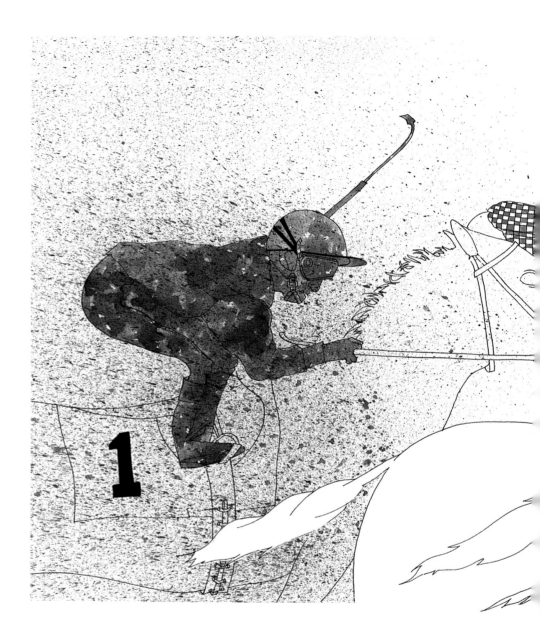

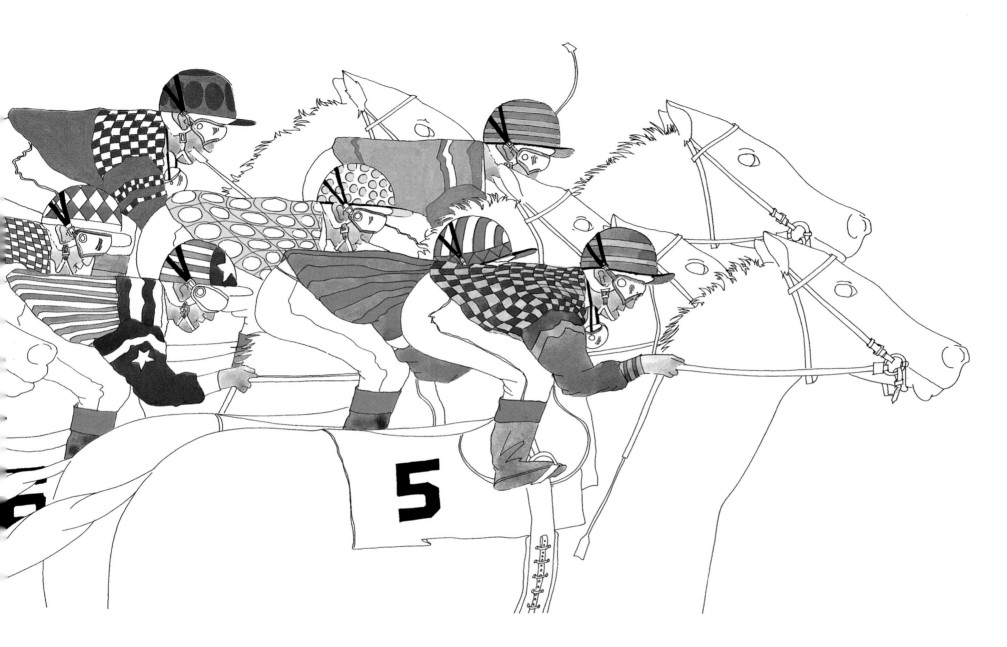

Mother Said There Would Be Days Like This (1988)
All I know is that you never want to be last—a simple lesson I once learned at the racetrack.

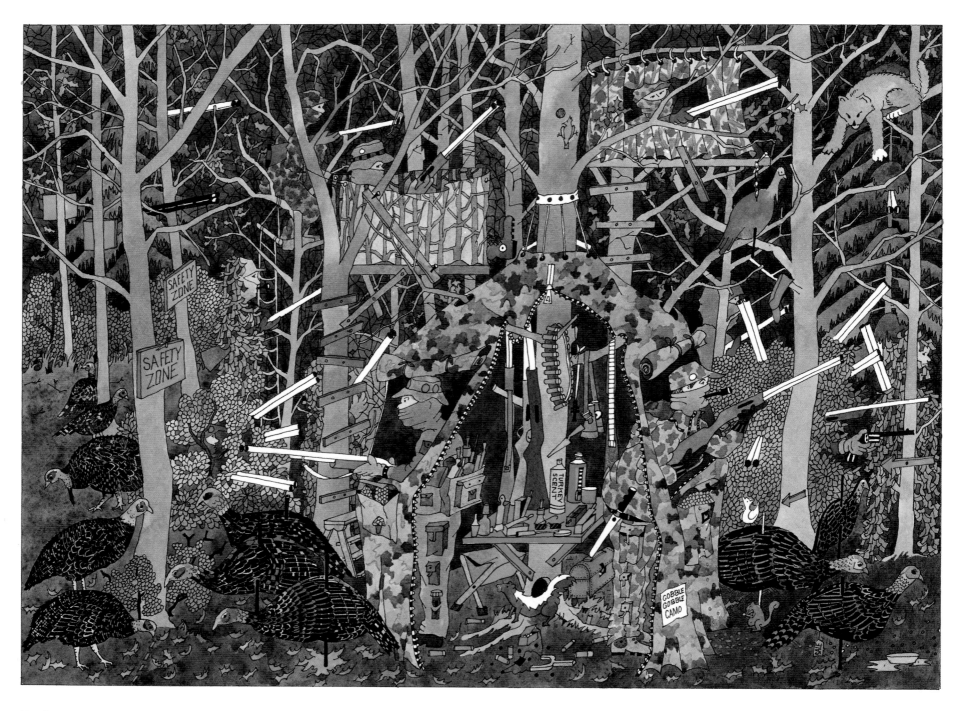

Turkeys (1999)

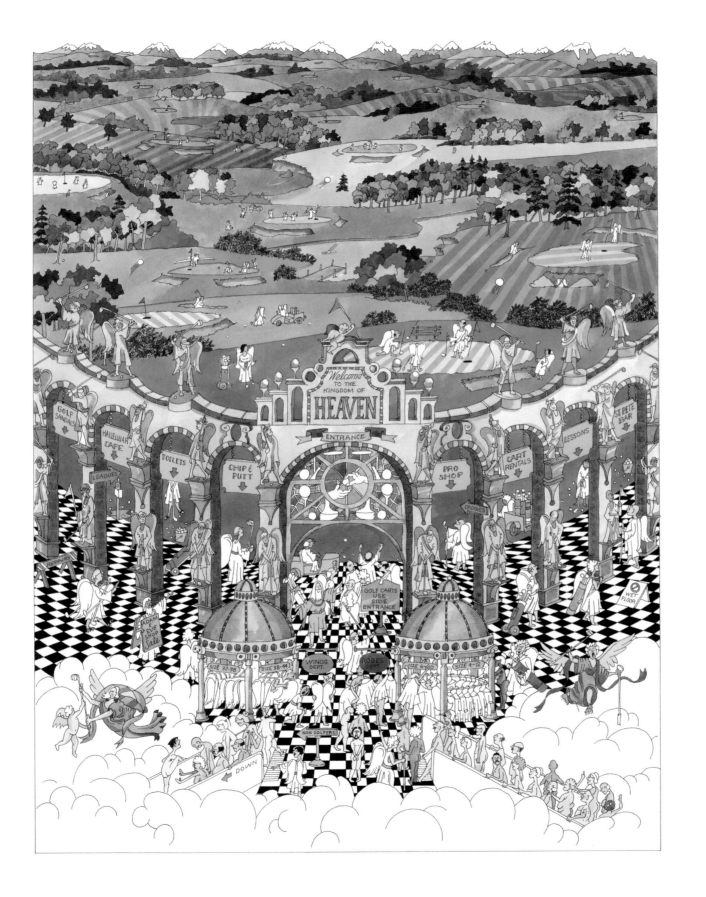

19th Hole (1997)

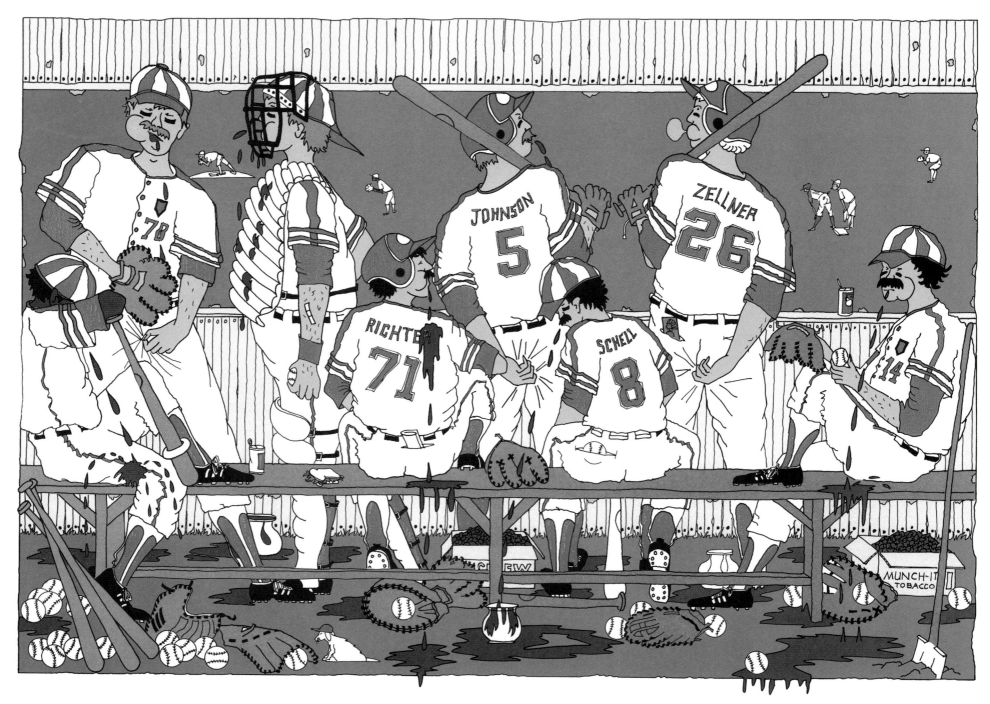

Play Ball (1990)

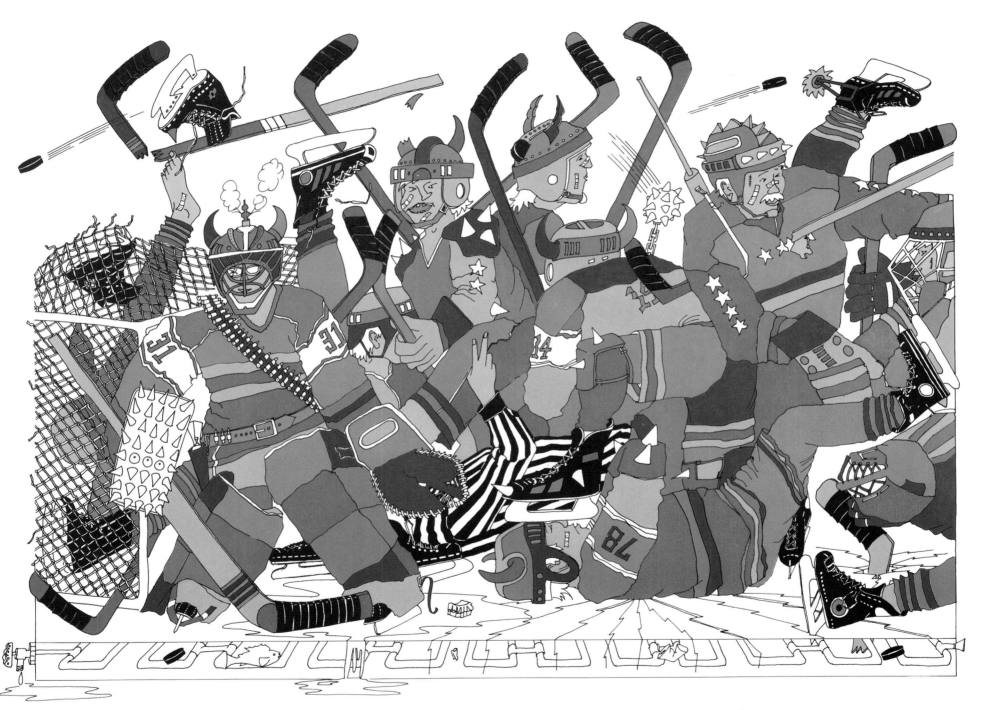

The Power Play (1990)

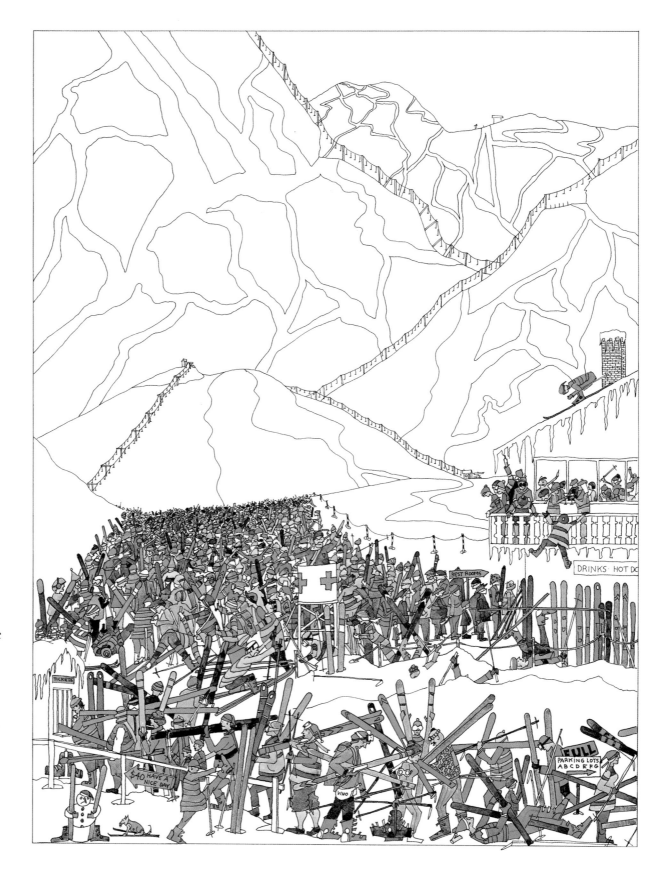

Skiing? (1984)

Then there is skiing. I get up at four A.M. to get to the slopes by eight. I put 200 pounds of equipment in the car and travel four hours and then wait in a lift line for another hour. I finally get to the top and then work my way down the mountain trying only to keep from falling and breaking my right arm. I had to do this drawing as soon as I got home.

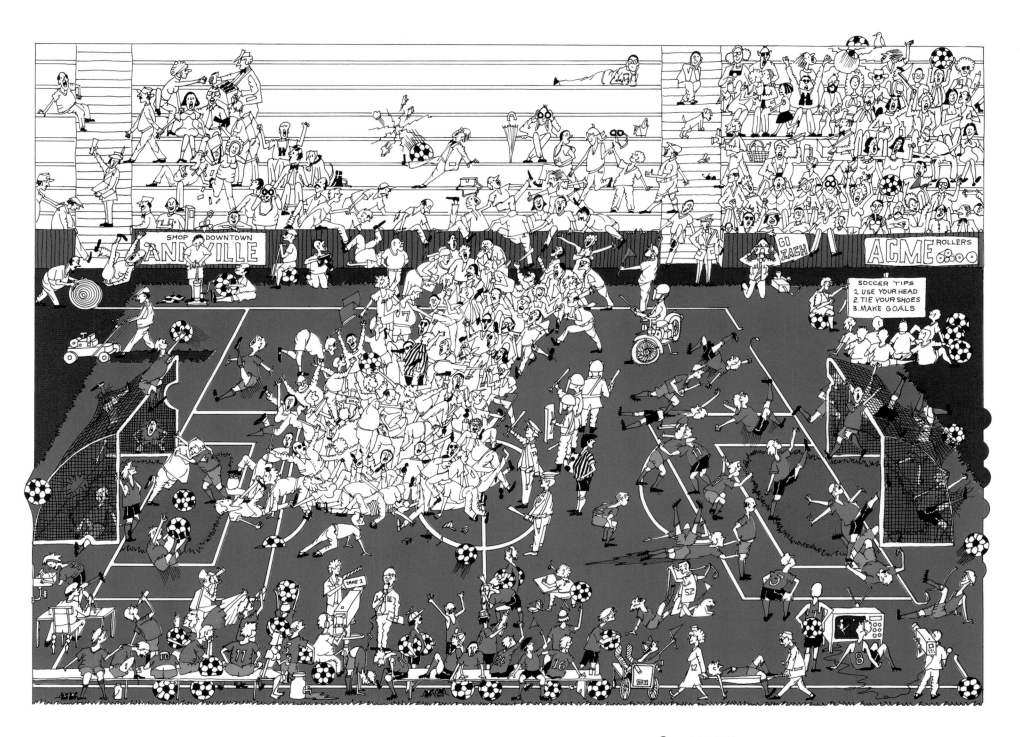

Soccer (1992)

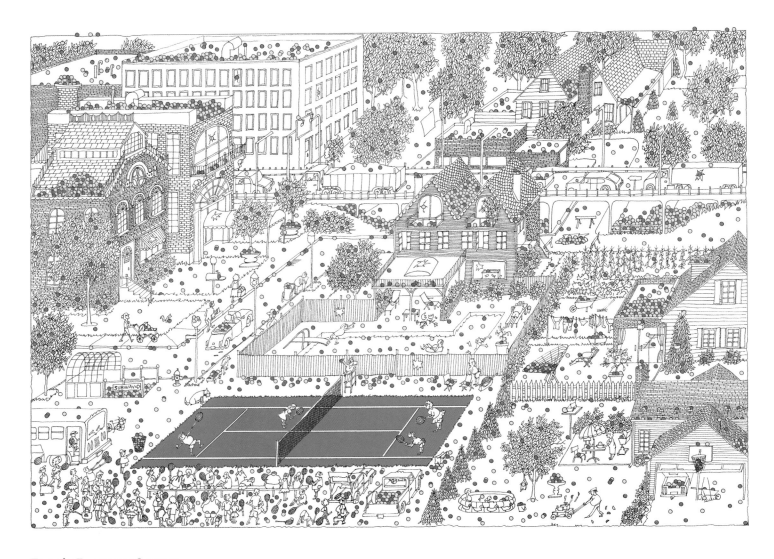

Tennis Everyone? (1986)

Tennis is a sport I've played only a few times. I gave it up because the fences surrounding the courts were never high enough. The original title of this piece was "It Takes a Lot of Balls to Play Tennis."

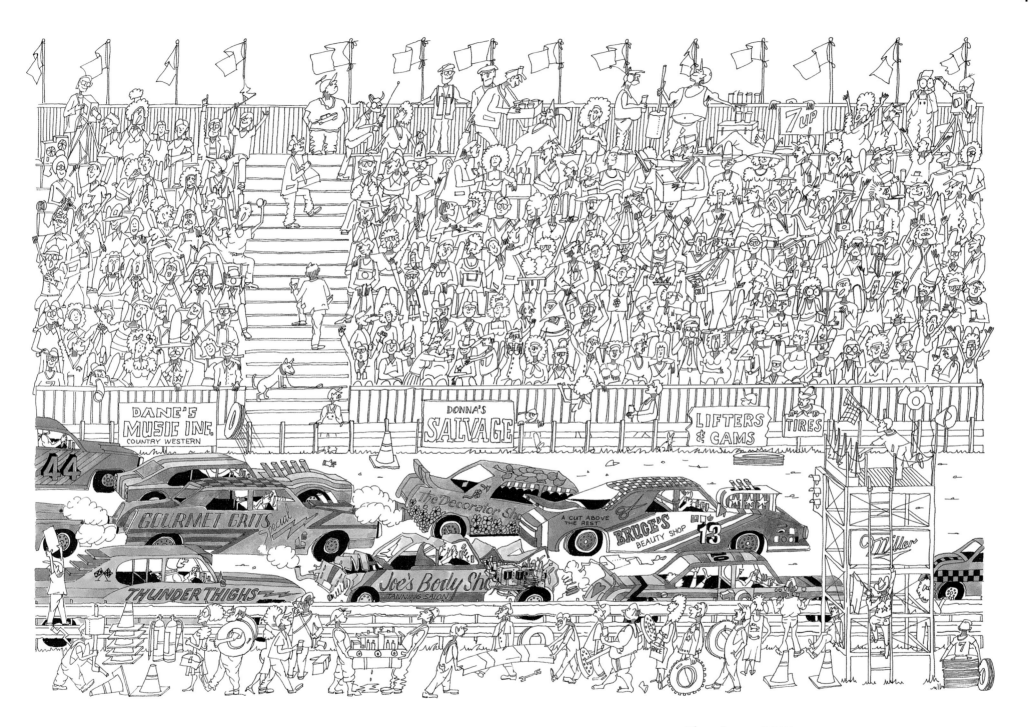

Time Lapse (1988)

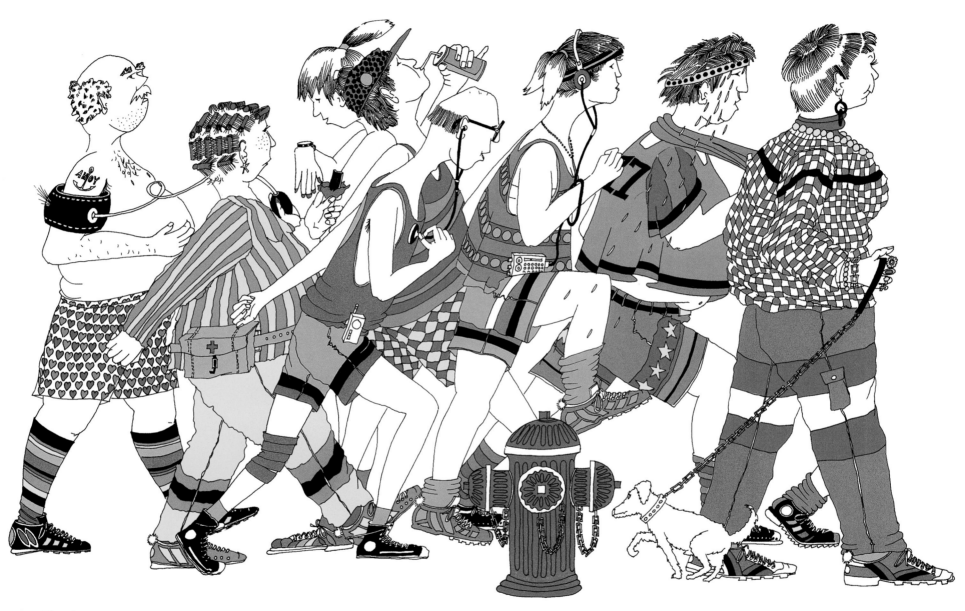

The Joggers (1990)

Play on Words

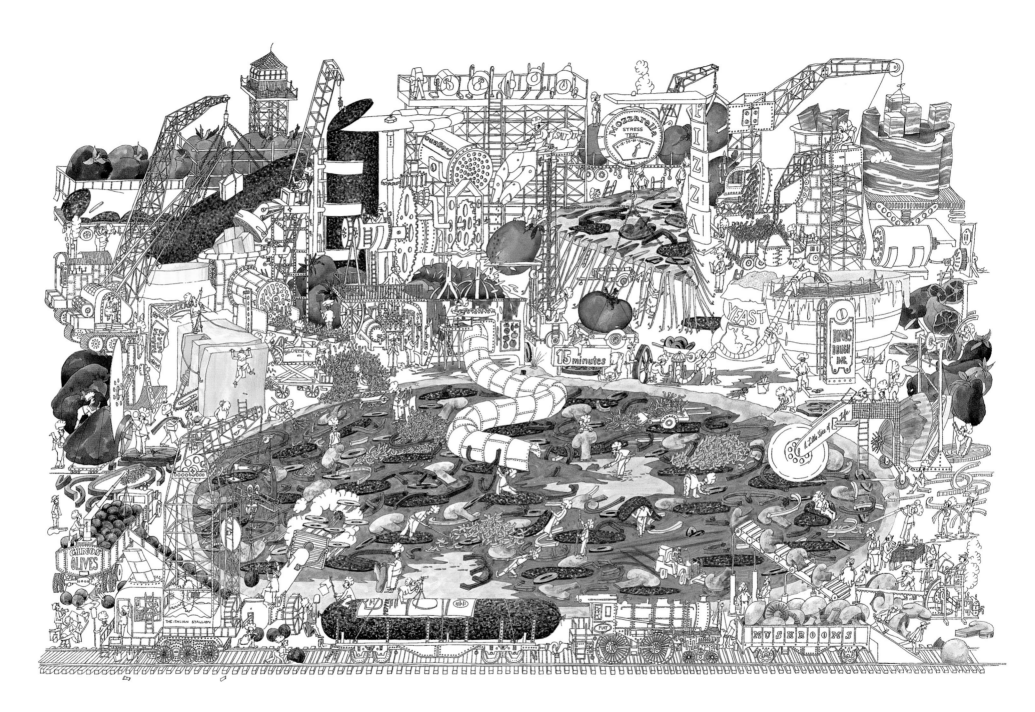

"The Works" (1989)

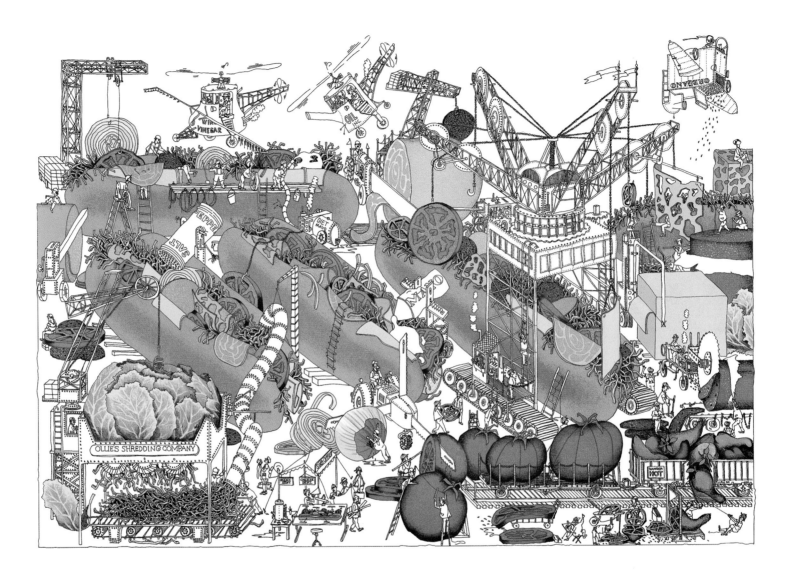

Sub Contractors (1989)

Many times a simple word or two will evoke an idea. My son came up with the title, and I immediately envisioned this drawing. Titles can be an important part of the success of a piece. In fact, sometimes the drawing means nothing without the title.

Training Bra Model #1040 (1982)

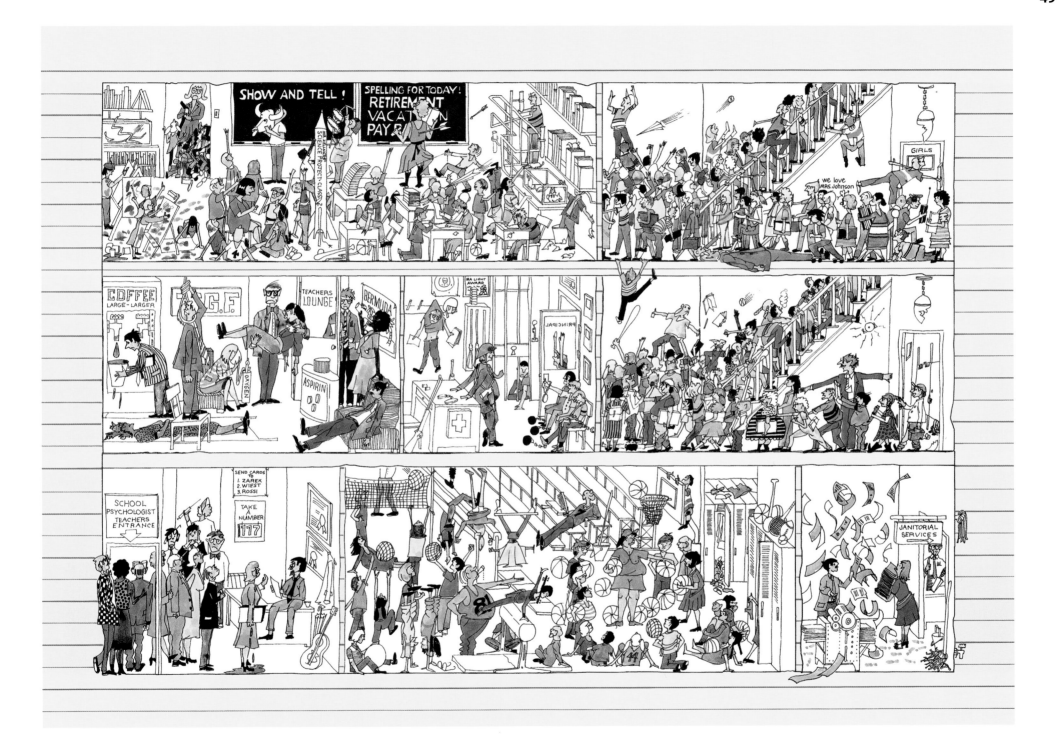

School Daze (1988)

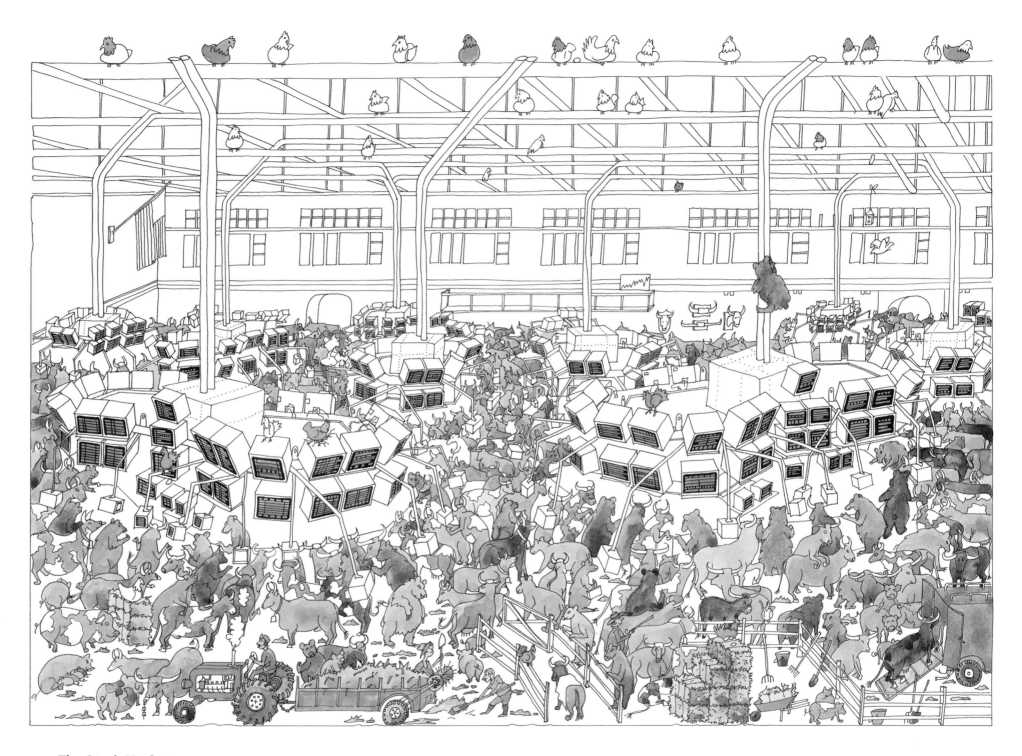

The Stock Market (1987)

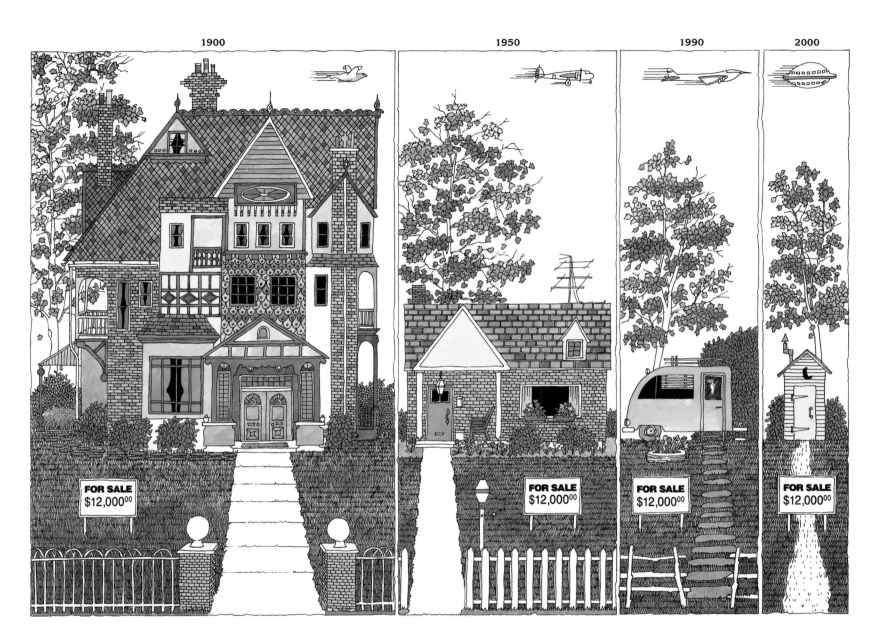

Unreal Estate (1990)

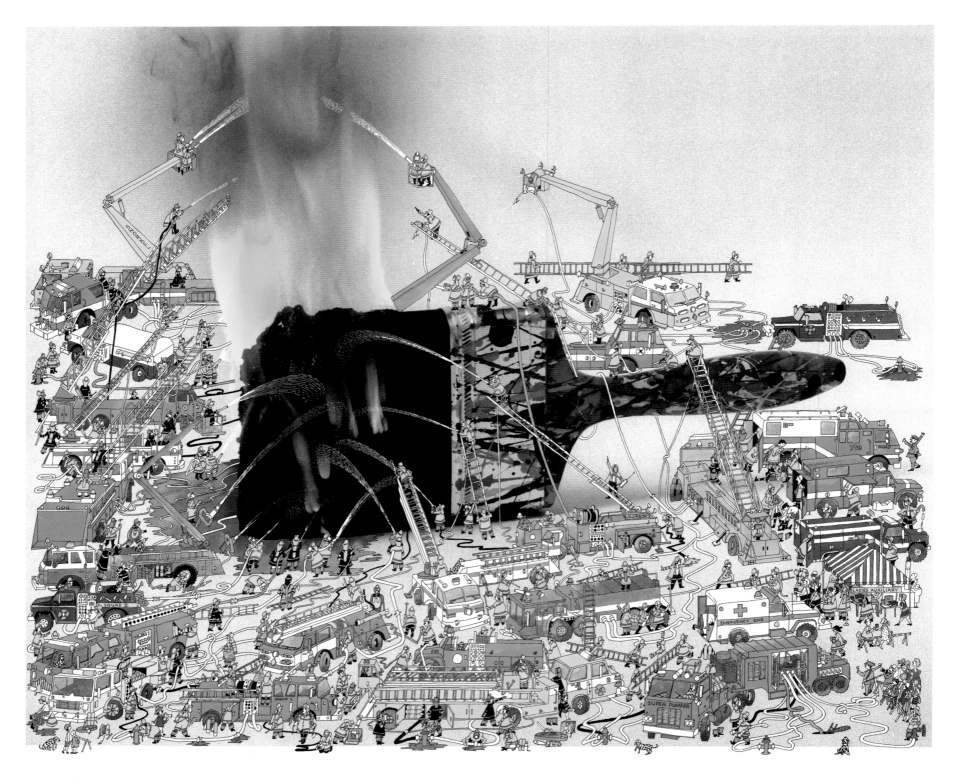

Brush Fire (1993)

Satire

I guess by nature I'm a skeptic. Drawings like "Keep America Beautiful" and "The Last Straw" show that I question the future. I'm dubious about where we are going and the things we are losing and replacing with something faster, bigger, or cheaper. In my own field I've seen the computer eliminate jobs once held by skillful people. I could spend another lifetime illustrating these doubts, but the drawings would not be pleasant. Some of these pieces at first seem funny but then aren't really if you think about them. I believe we've gained some things and lost other things that in the end might be more important than what we've gained. Is our civilization advancing or have we headed south?

details from "The Last Straw"

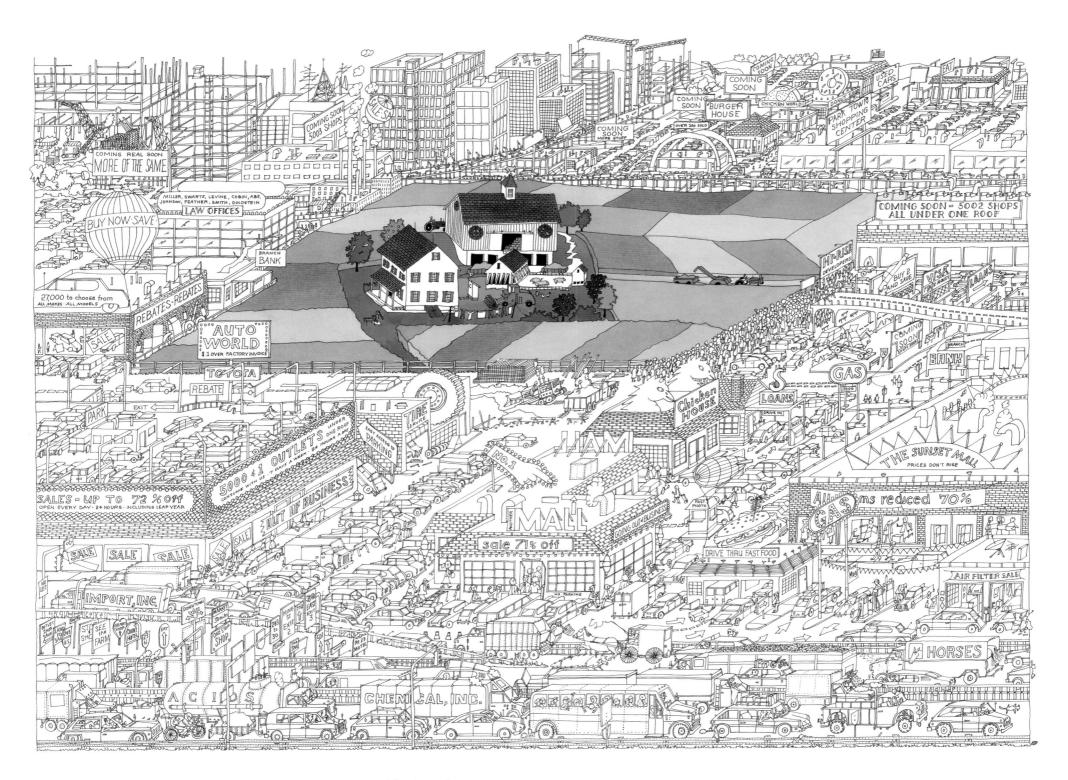

The Last Straw (1983)
There's air pollution, but people rarely talk about visual pollution.

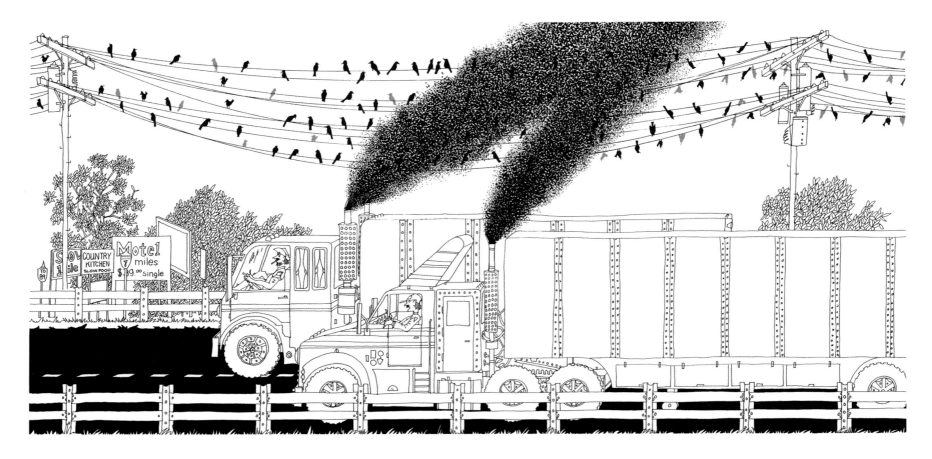

EPA is for the Birds (1989)

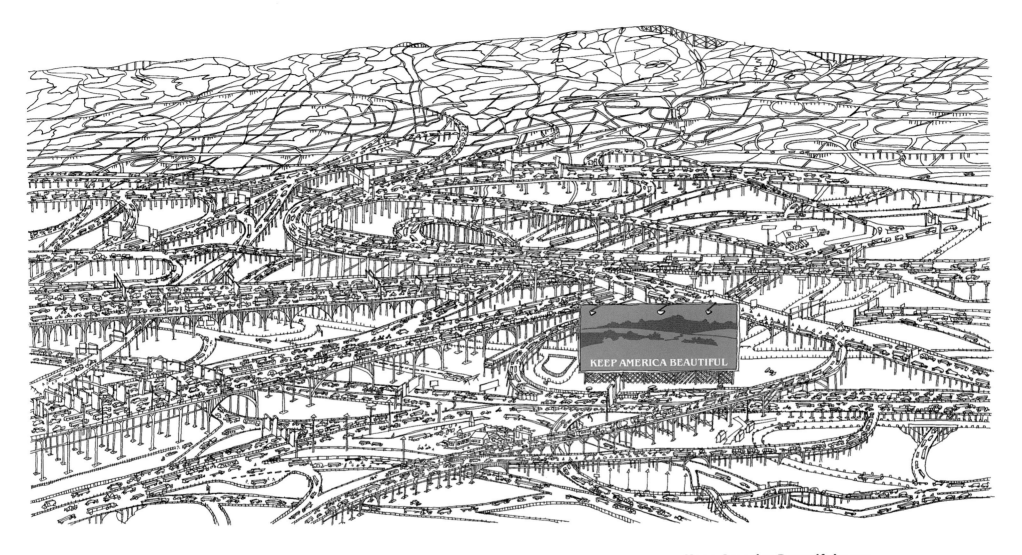

Keep America Beautiful (1981)

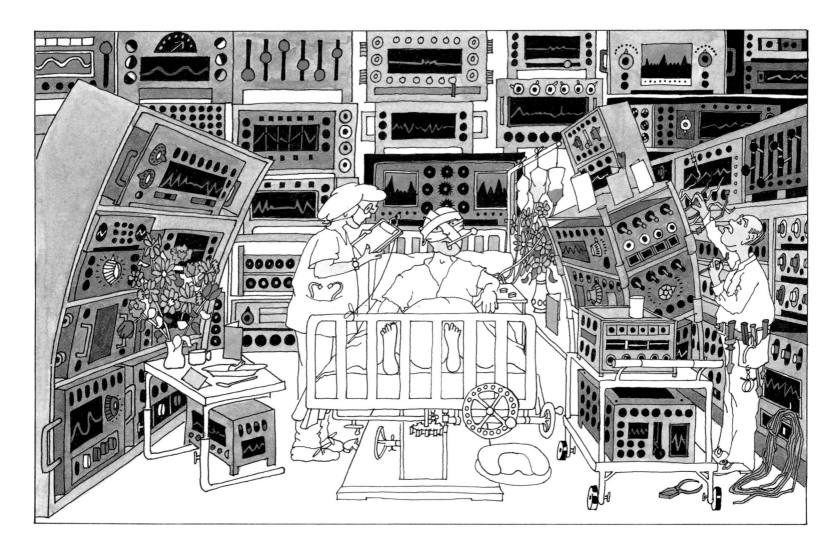

Take Two Aspirin and See Your Electrician (1996)

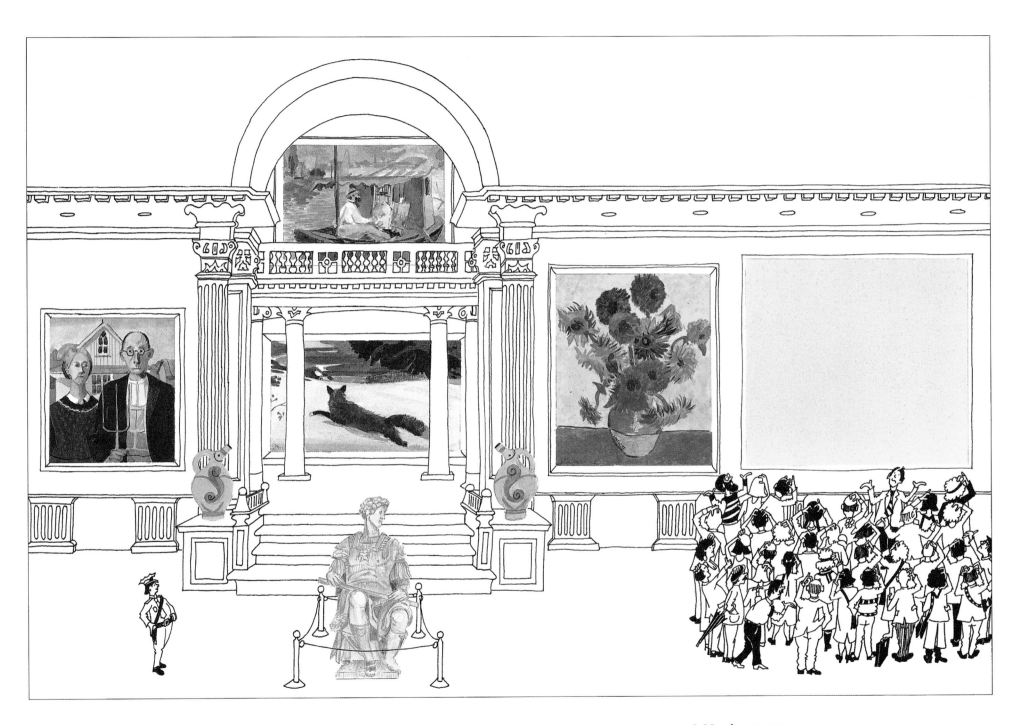

A Musing (2002)

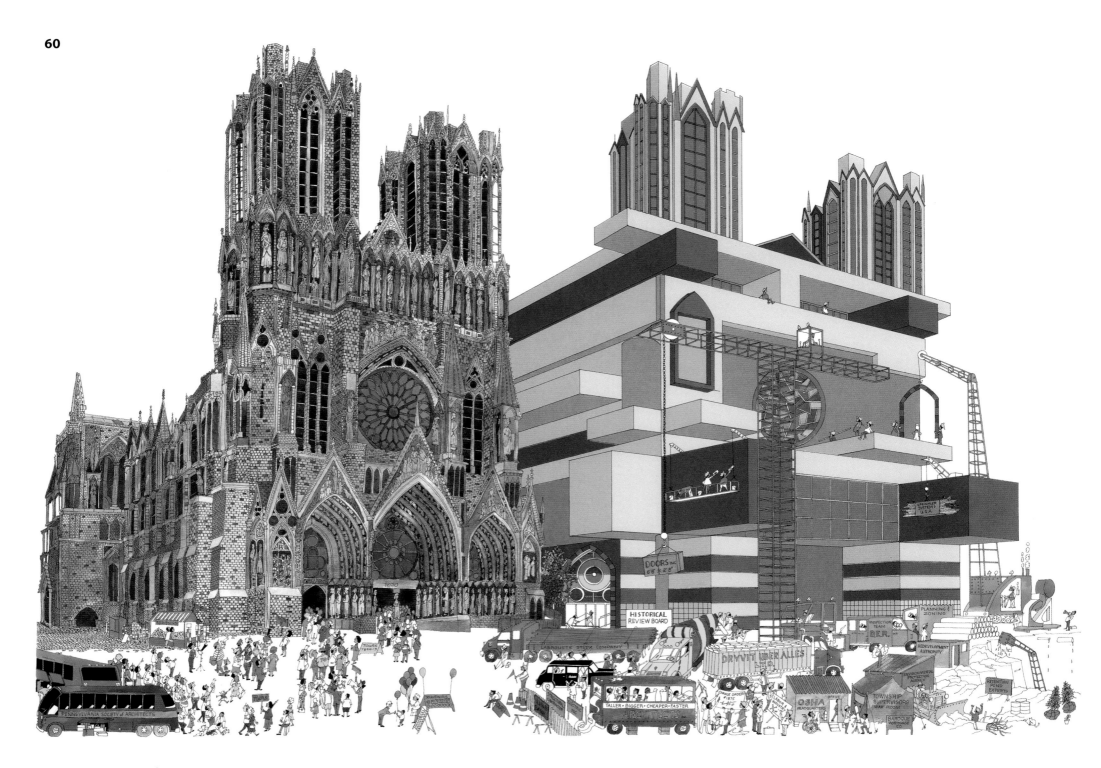

Less is More (More or Less) (1993)

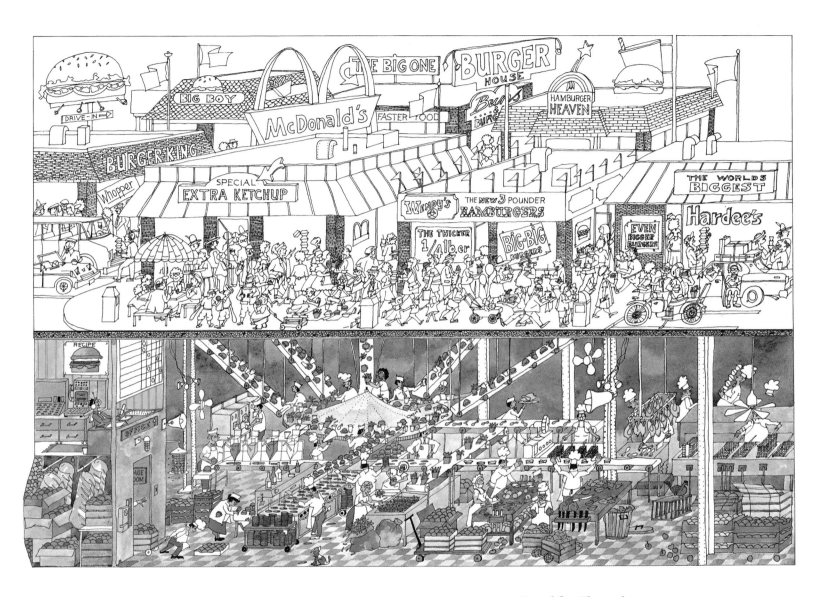

Food for Thought (1985)

No Maintenance, Everlasting Beauty (1977)

Hobbies

Like sports fans, some hobbyists don't know when to quit and are content to
live happily ever after in their make-believe worlds. Building models and
playing with my toy trains certainly keeps me away from real life.

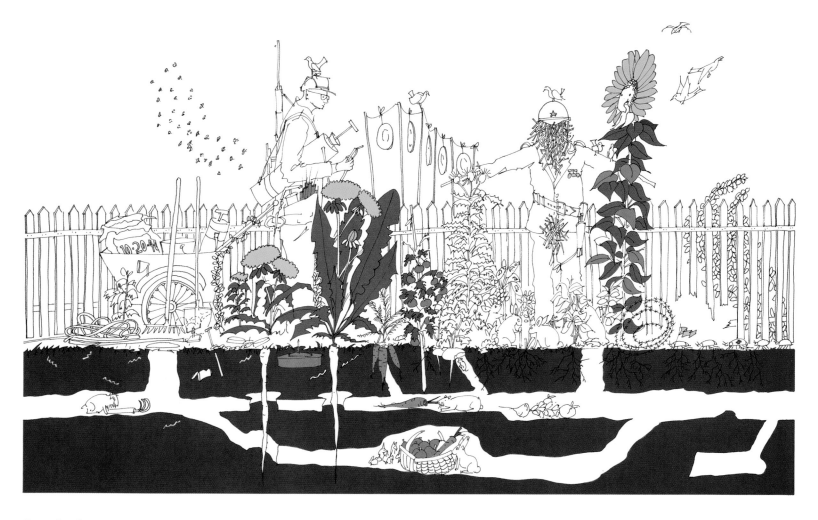

"Gardening" (1982)

I've always had a garden. But I'd be willing to bet that if I gathered together all the tomatoes I've grown over the past thirty years I could not fill a basket. The same goes for every other thing I've ever tried to grow.

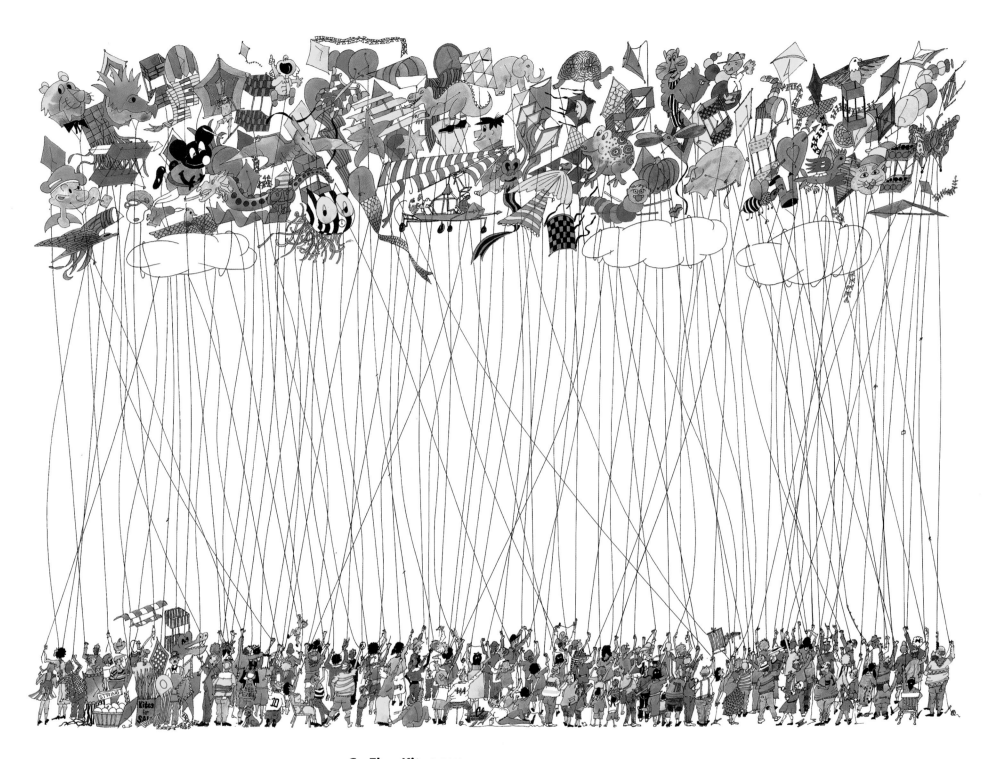

Go Fly a Kite (1988)
Drawings like this one or "Gentle Giants" or "Country Quilters" really have more to do with color and design than anything else. They aren't meant to challenge or provoke or evoke a great deal of thought. I meant them to be fun and colorful first and foremost.

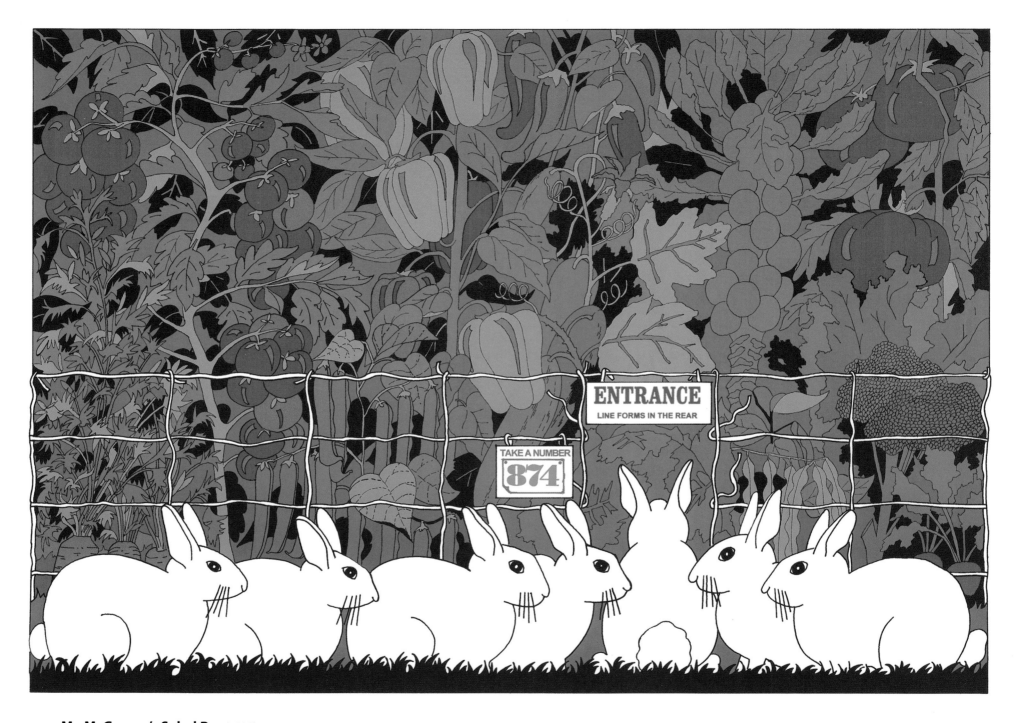

Mr. McGregor's Salad Bar (1995)

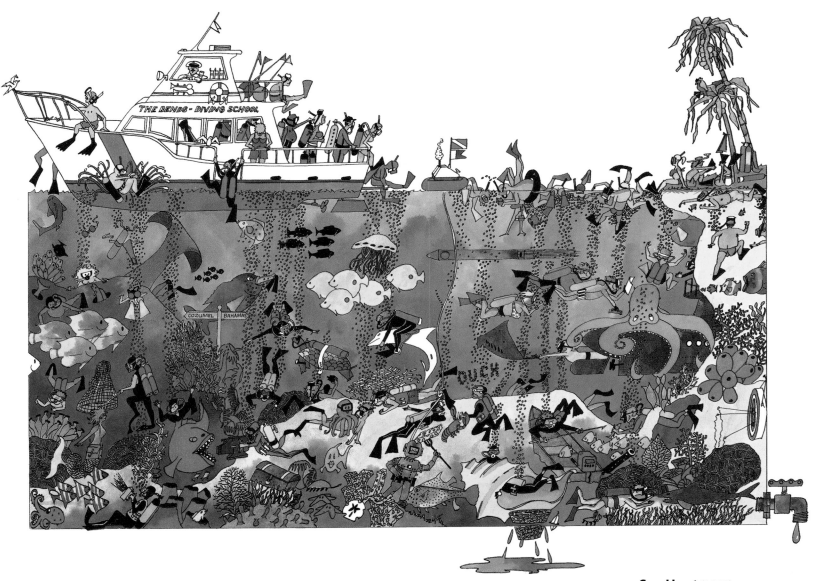

Sea Hunt (1992)

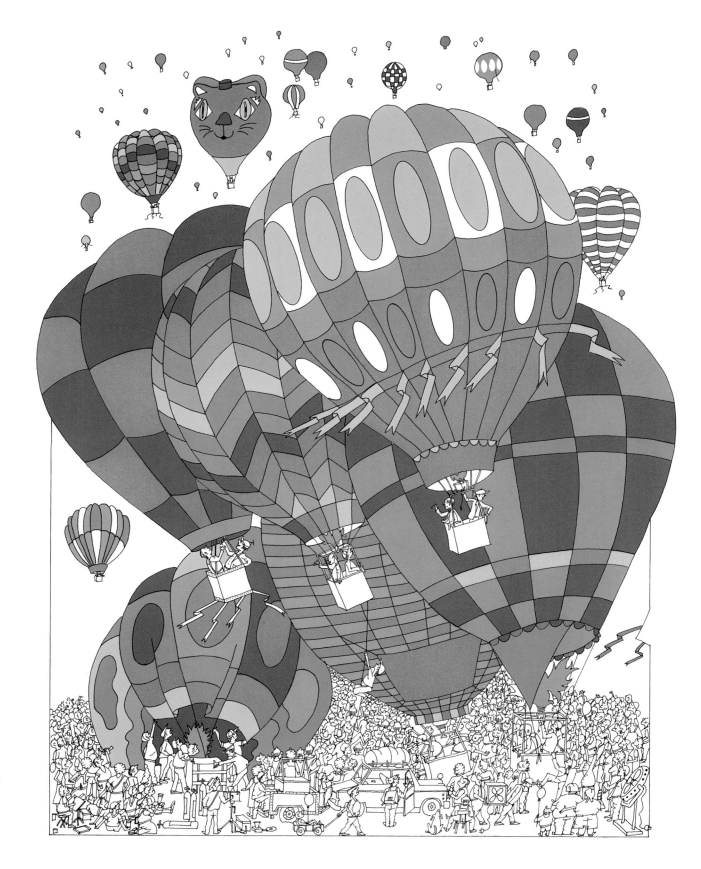

Gentle Giants (1992)

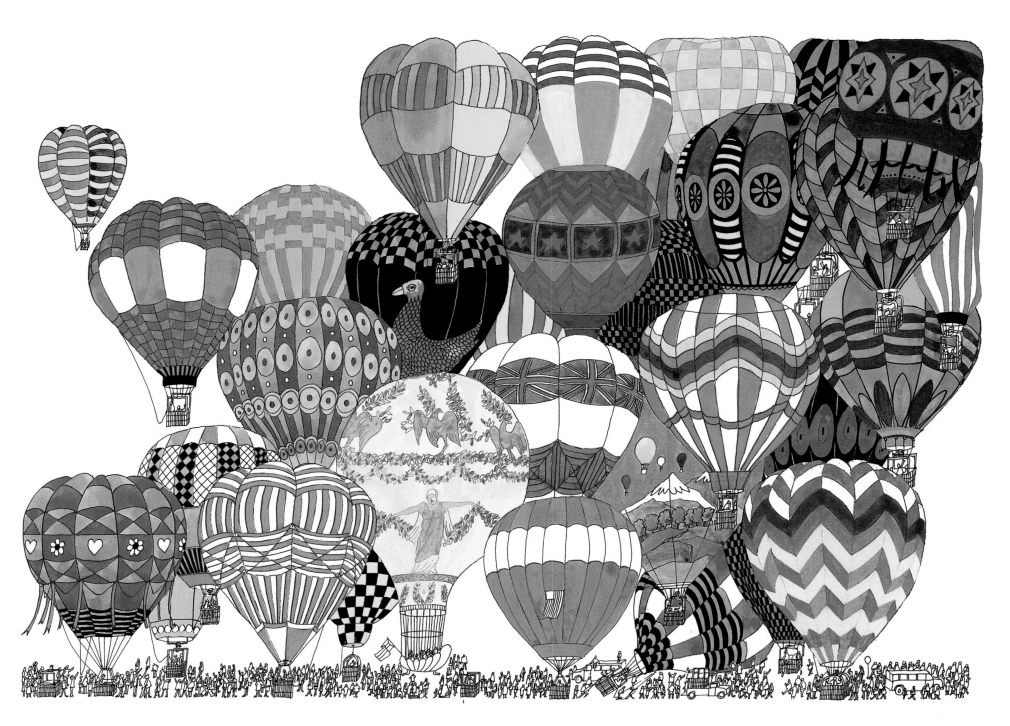

Floating Fantasies (1988)

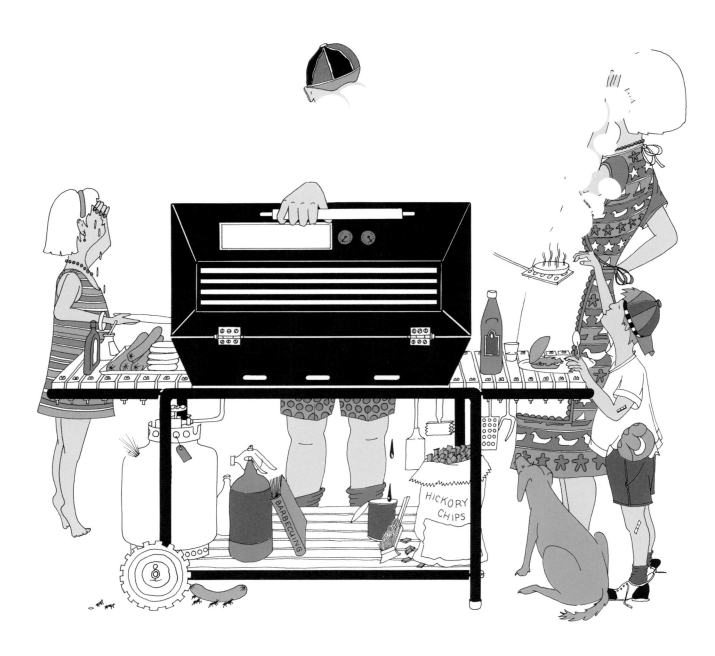

What's Cooking (1992)

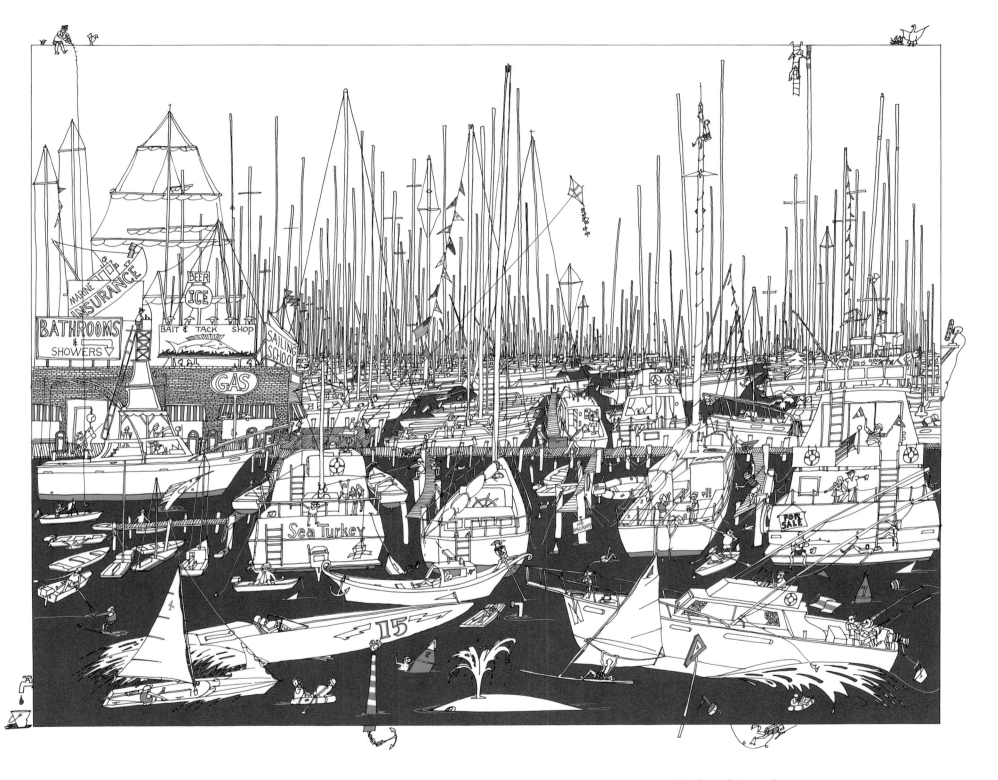

Weekend Captains (1990)

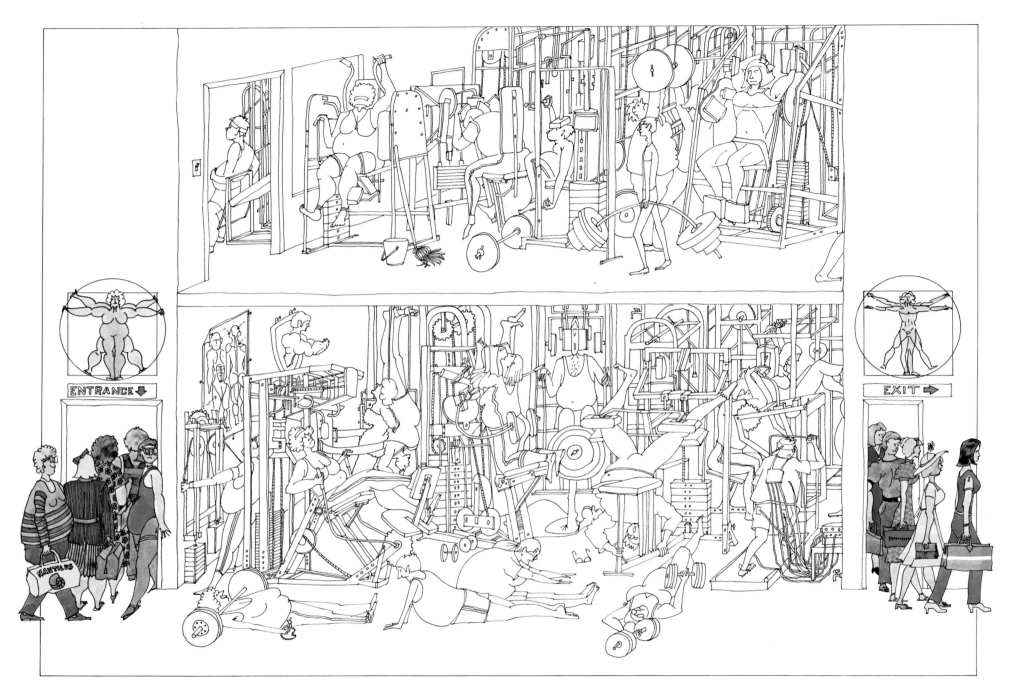

The Gladiators (1983)

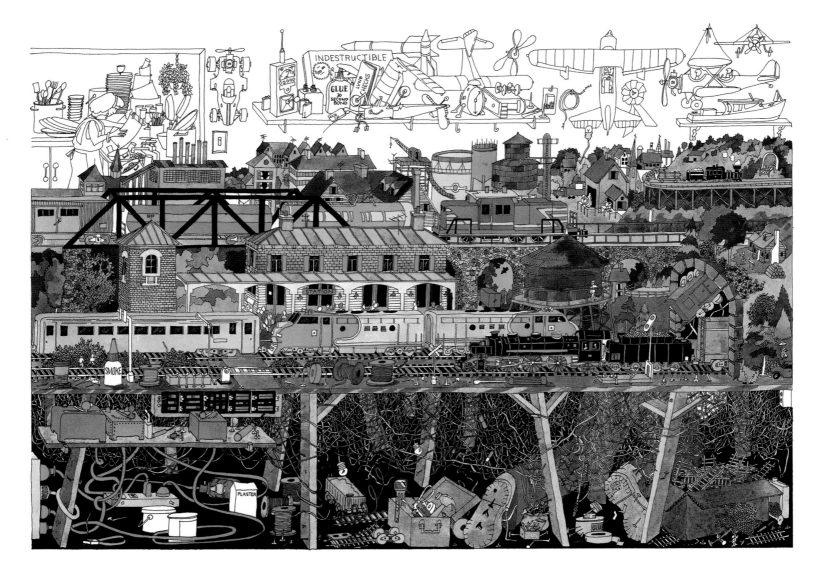

Big Boys and Their Toys (1994)
You know what they say: "The guy with the most toys wins." I will win.

Original lithographs and silk-screened prints require color overlays. Each color is printed separately and needs a separate drawing, so a finished print with ten different colors needs ten different drawings done in black or halftones of black. To make the overlays for a ten-color print, I use ten pieces of frosted acetate cut to exactly the same size. I put a finished ink drawing on a light table and one piece of acetate over the drawing, then fill in with black all of the parts of the drawing I want to print in a certain color. When that's done, I get a new piece of acetate and fill in with black all of the parts that will be another color. I do this ten times—all of the parts of a drawing that will be red are on one piece of acetate, all of the parts that will be blue are on another piece, and so on. (Four overlay drawings for "Sunday Sailors" are shown here.) The first time I see a complete ten-color printed piece is after the tenth color has been printed.

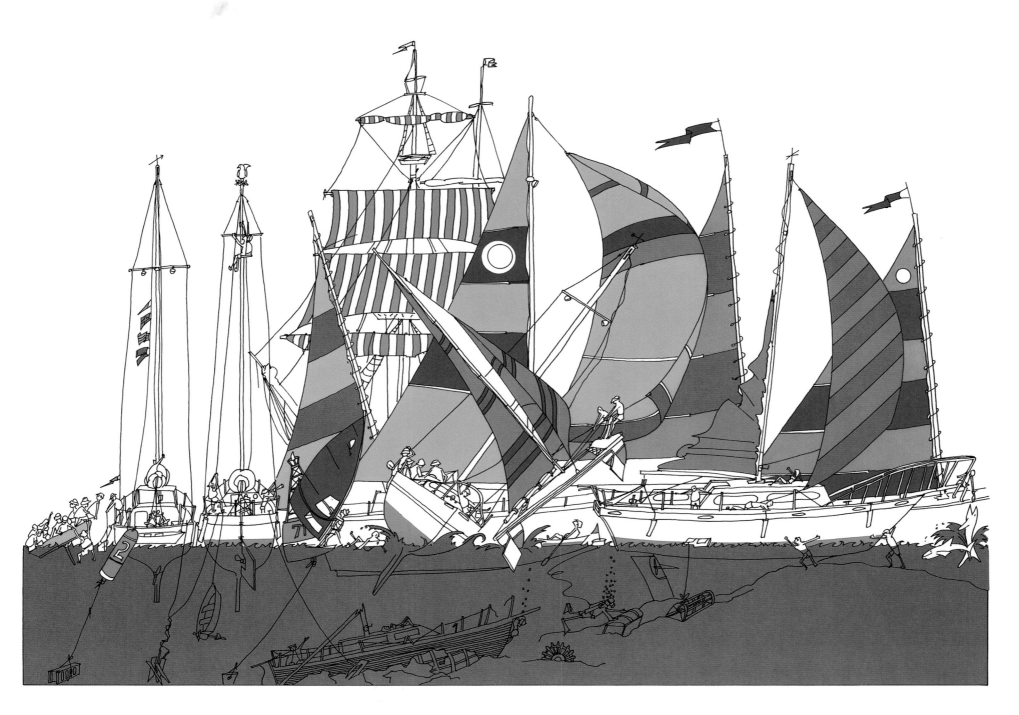

Sunday Sailors (1995)

details from "Harmony"

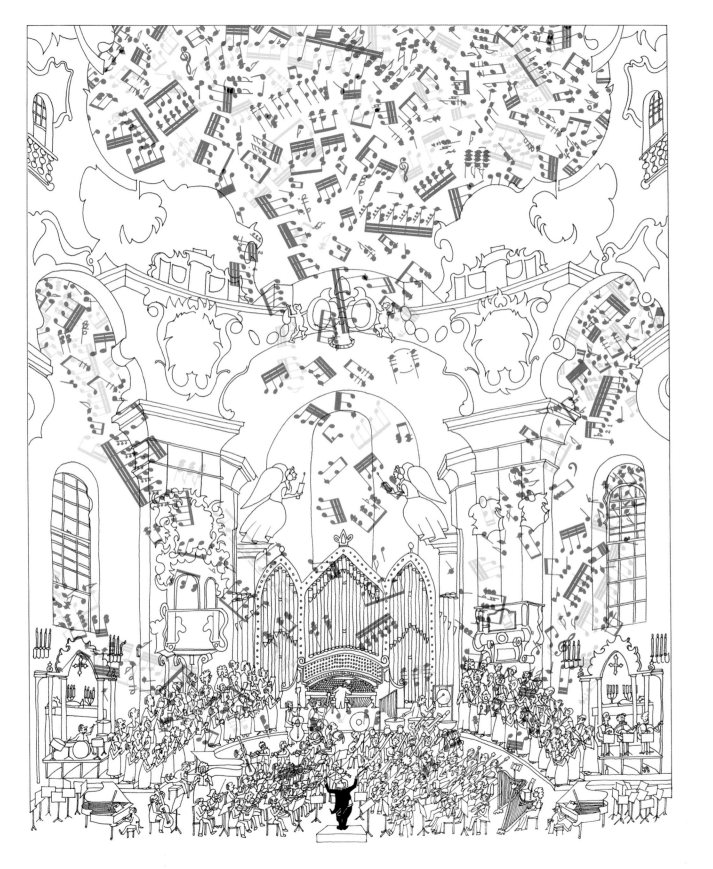

Harmony (1988)

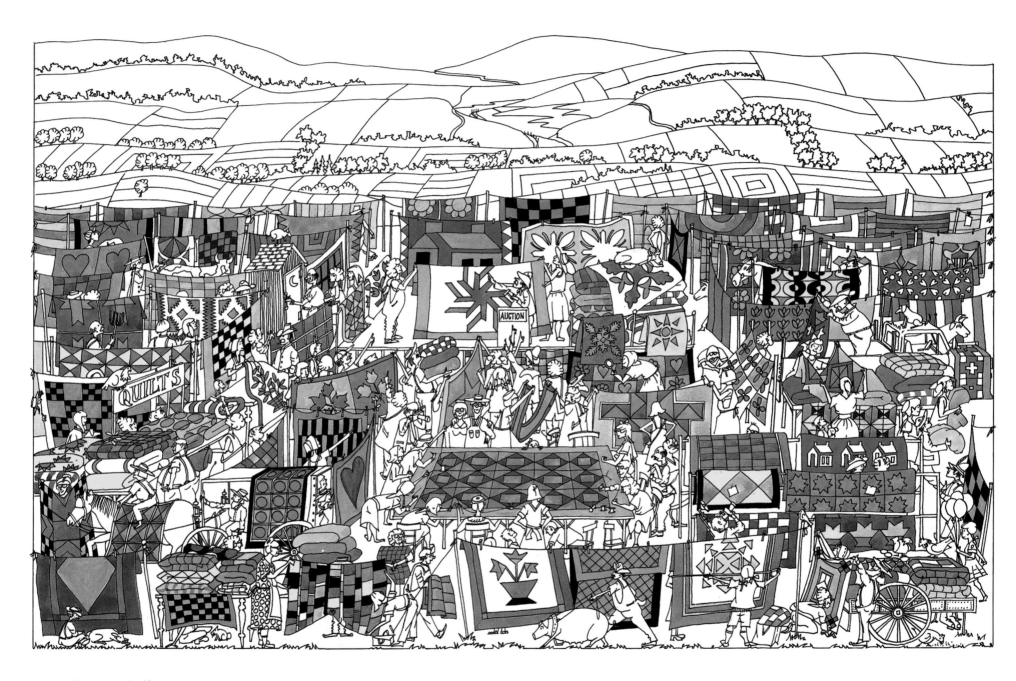

Country Quilters (1992)

Vacation & Travel

I love it when people go on vacation. They wait in long lines to get there, to eat out, and to get back home. They pack for two hours, unpack, pack again, then unpack when they're back. They squeeze into a spot on a beach and swim with sharks and do other dangerous things. They get burned by the sun and squashed by other vacationers. They try to see Europe in five days and spend most of that time waiting for someone in front of them to get on the bus. To get away from it all they set up camp two feet away from another camper who wanted to get away from it all, too. They pack everything, including the kitchen sink, so that being away from home feels just like being at home.

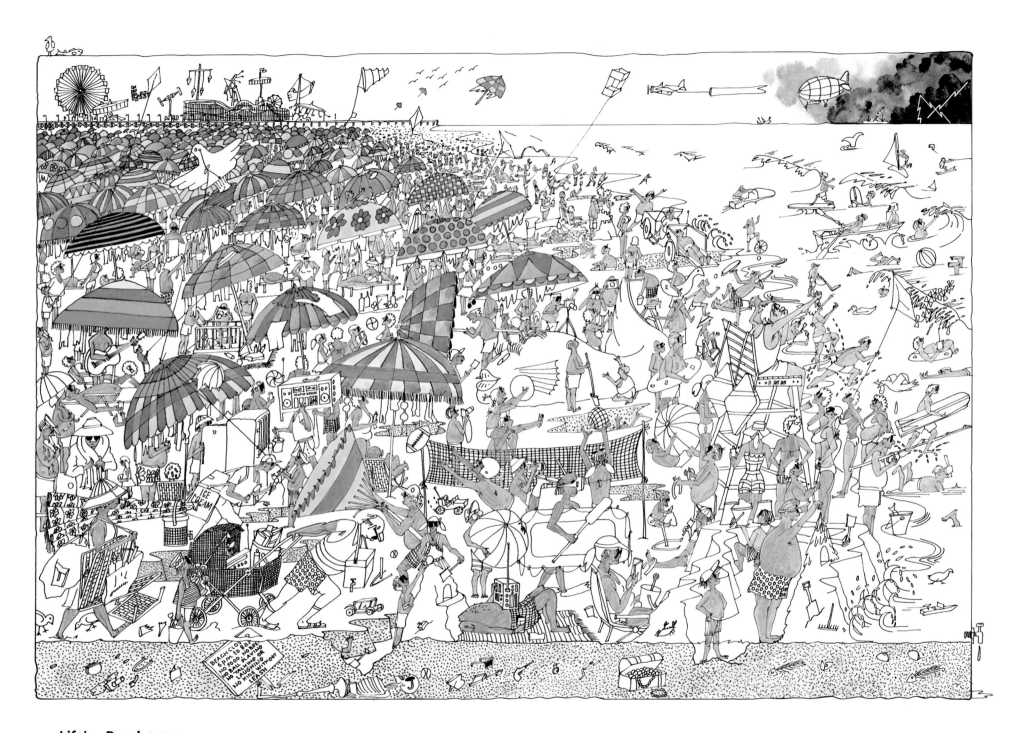

Life's a Beach (1986)

If most people were paid to go on vacation they wouldn't go. After most vacations you need another week to recover.

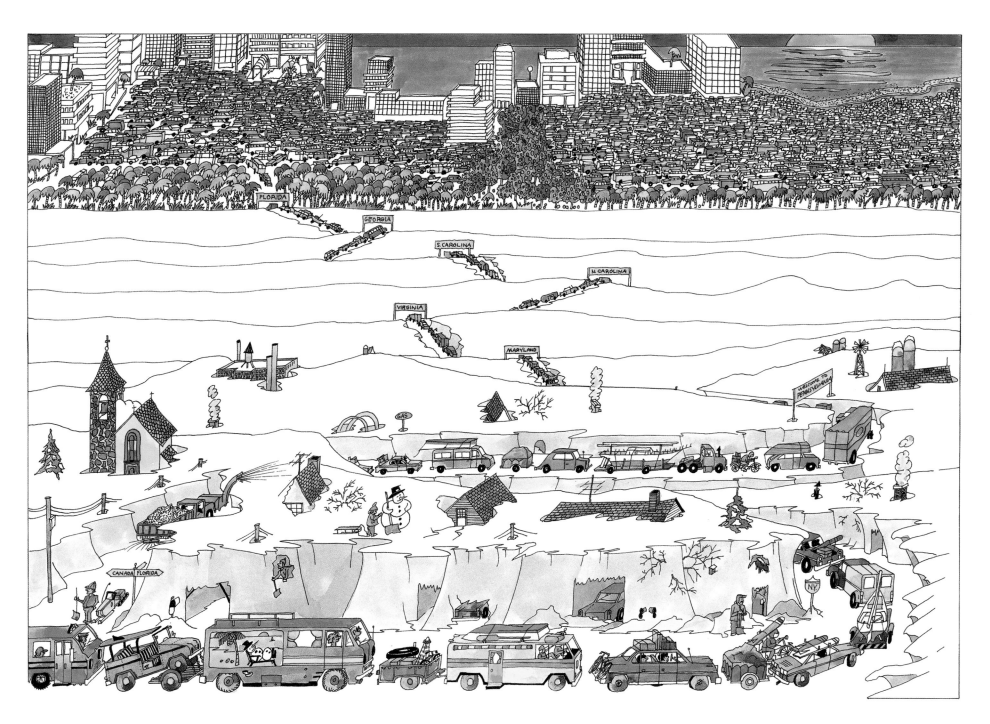

Migration of the Snowbirds (1987)

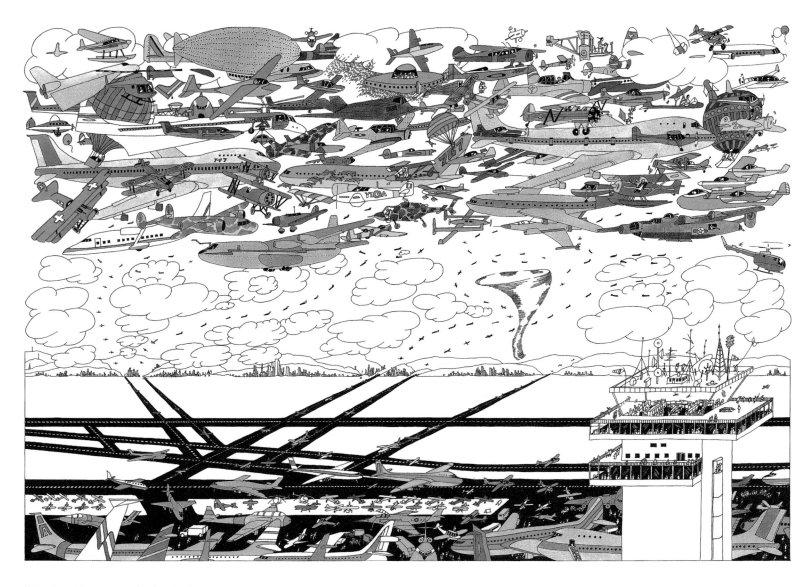

"Fasten Your Seatbelts" (1996)

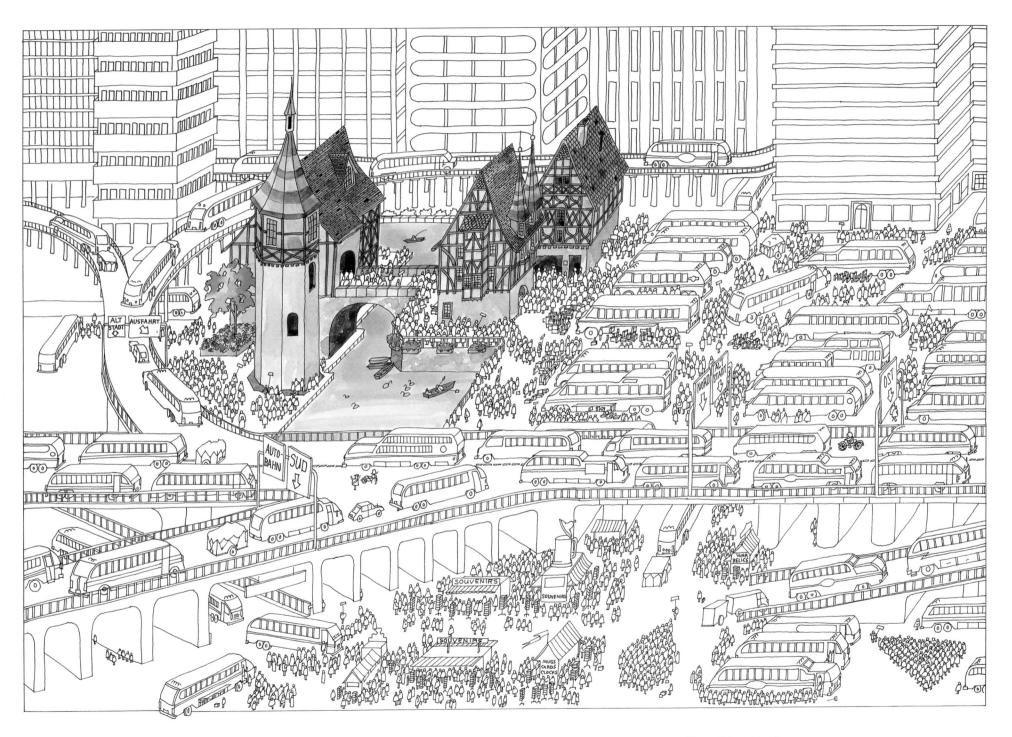

Next Stop Venice (1987)

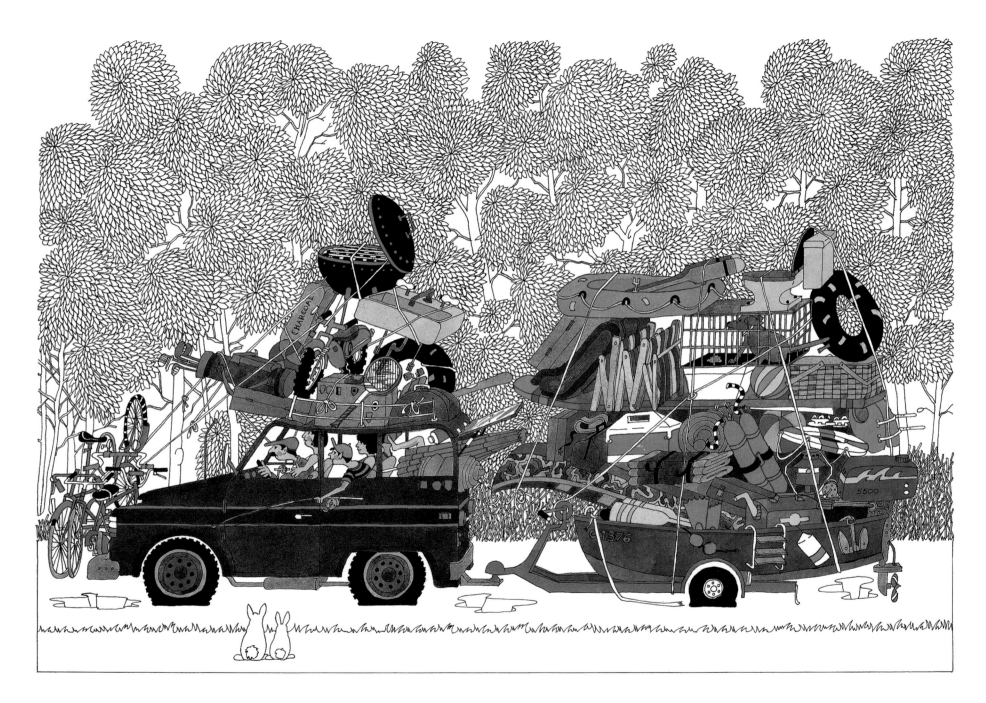

Weekend Get-a-Way (1994)
I have a rule in our home: you carry your own baggage. You'd be surprised how light the bags
become.

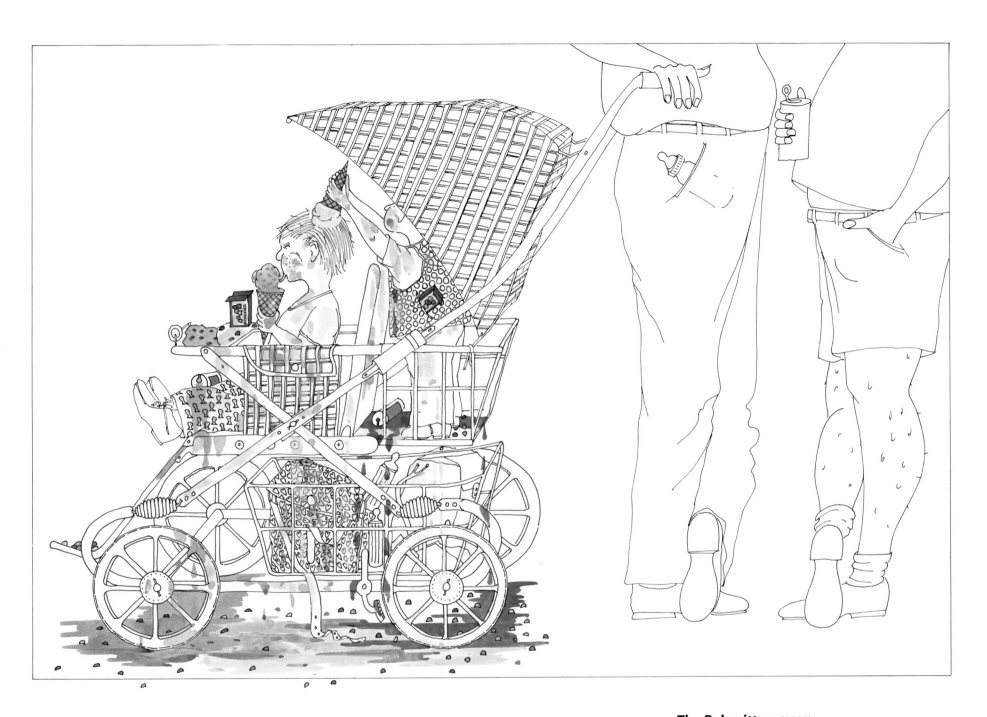

The Babysitters (1985)

details from "A Day in Lancaster County"

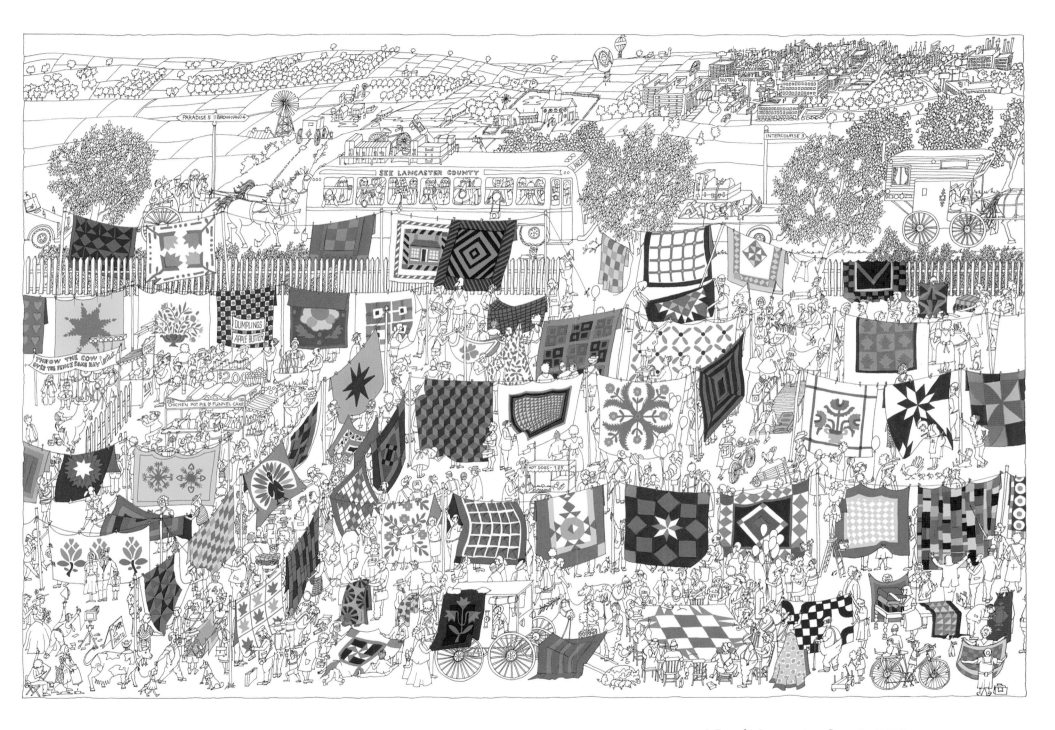

A Day in Lancaster County (1991)

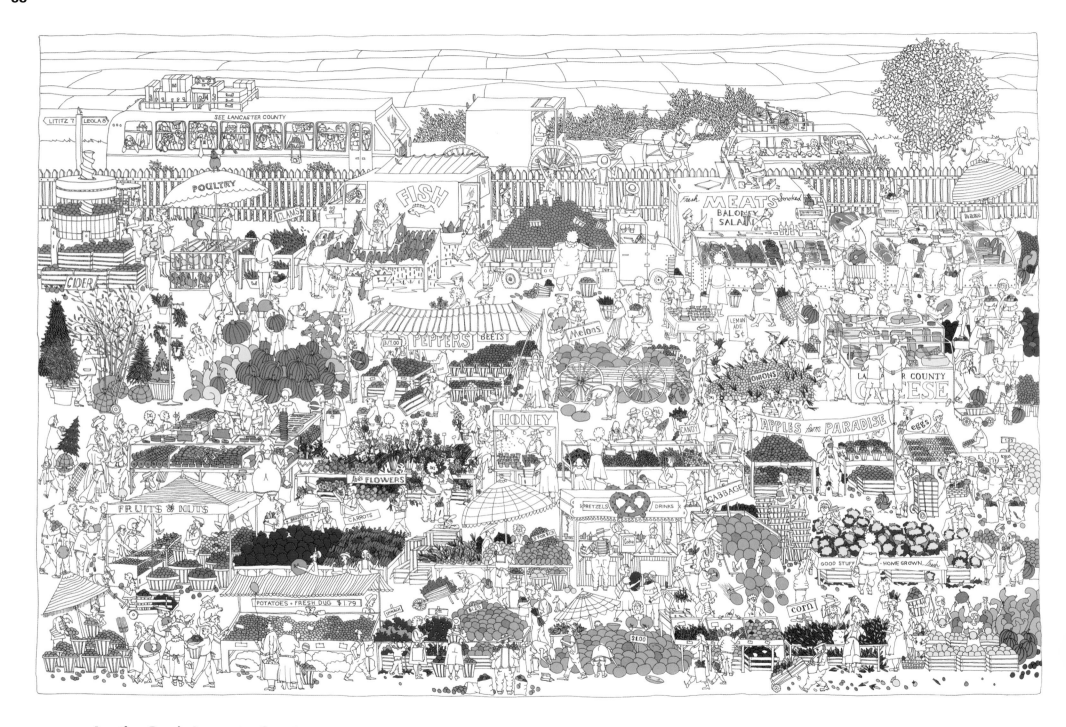

Another Day in Lancaster County (1992)

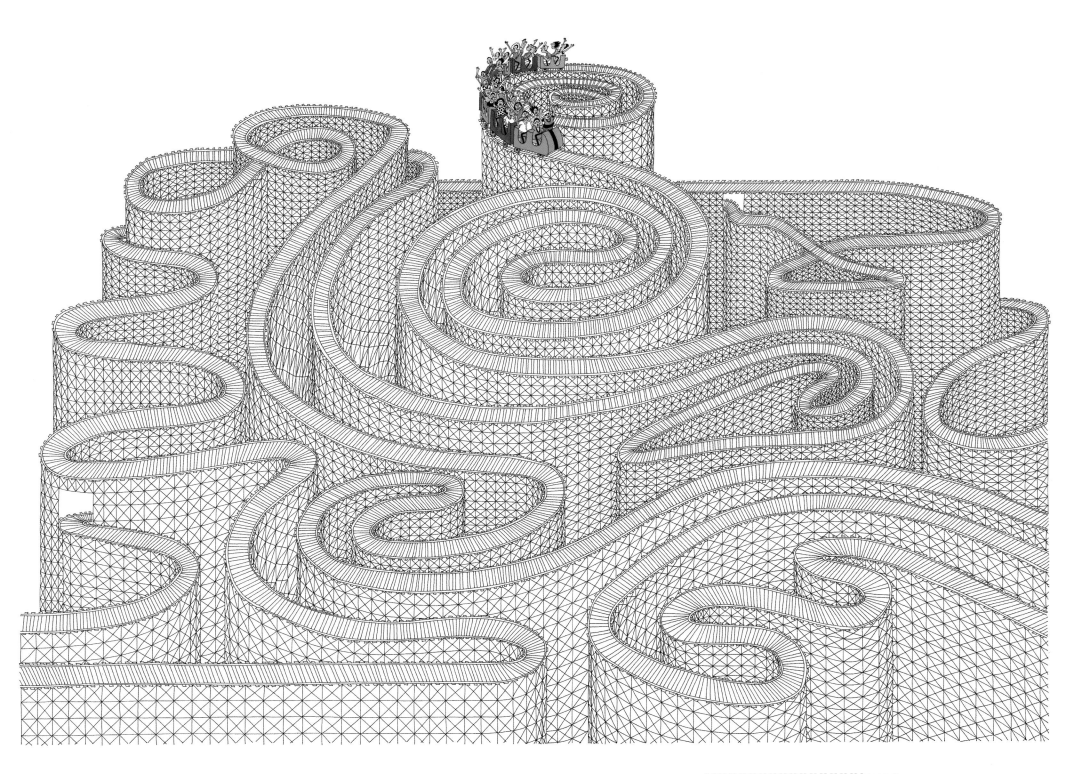

AHHHHHHHHHHHHHHHH (1996)

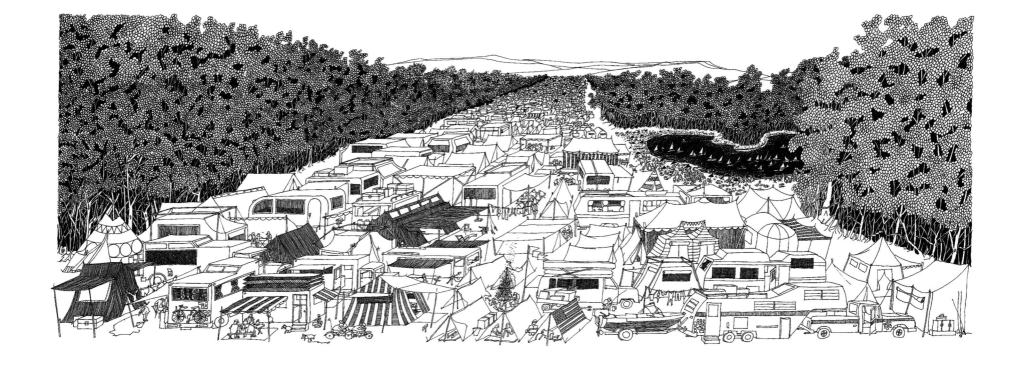

Camping USA (1978)

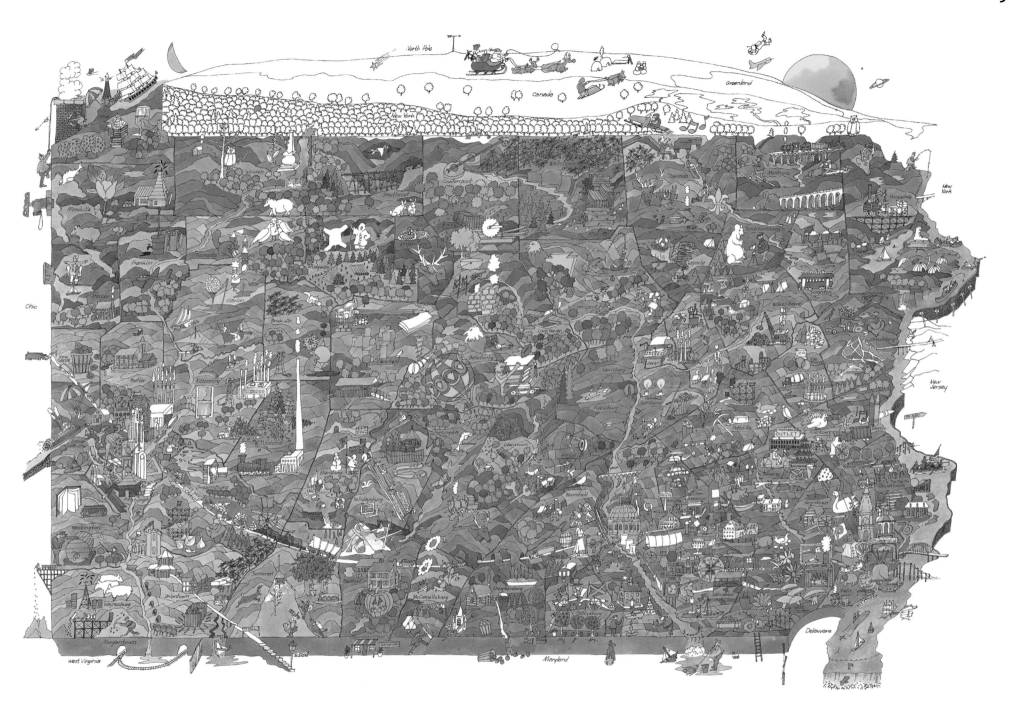

Pennsylvania Map (1981)

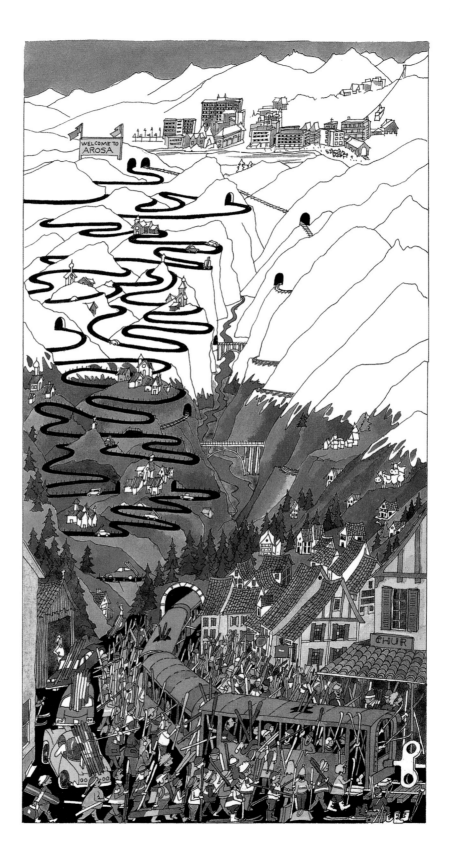

The Way to Arosa (1995)
The next four drawings were done for galleries in Europe. Many of them were bought by tourists on vacation. I'm reminded how we always have more to unpack than we did to pack.

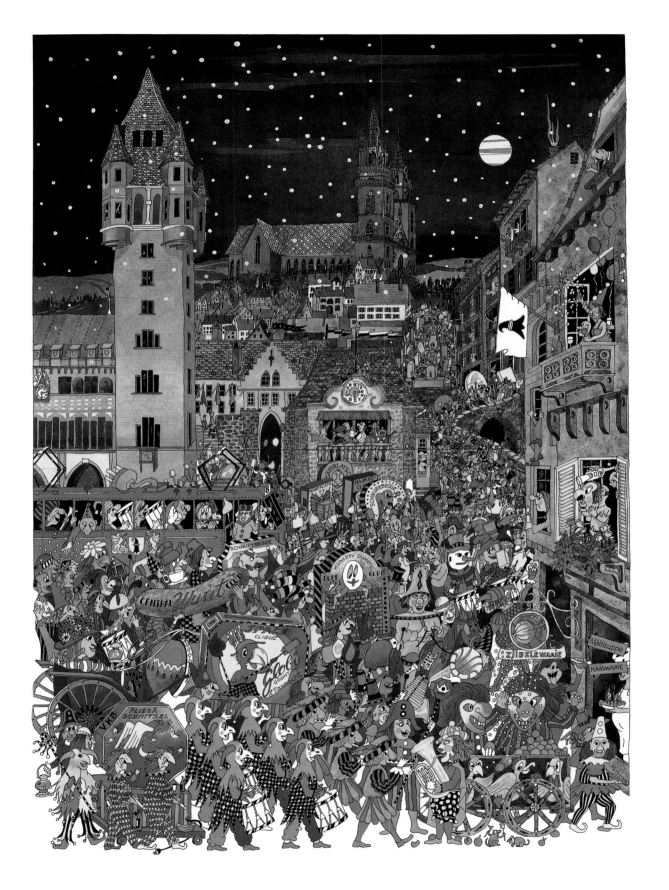

Basler Fasnacht (1994)

details from "A Day in Freiburg"

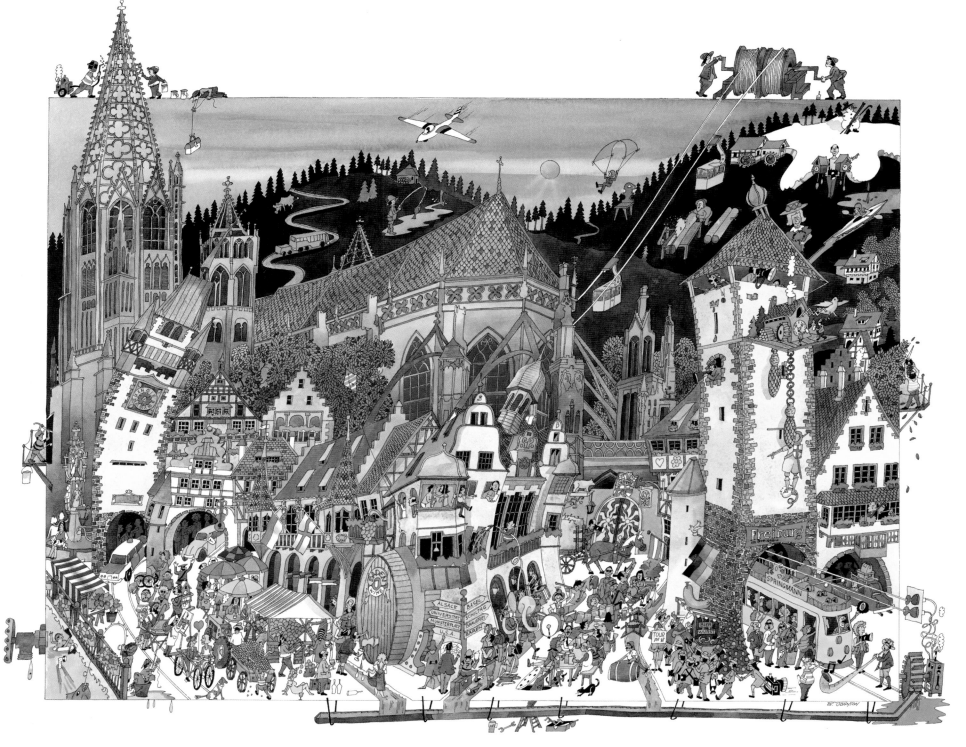

A Day in Freiburg (1999)

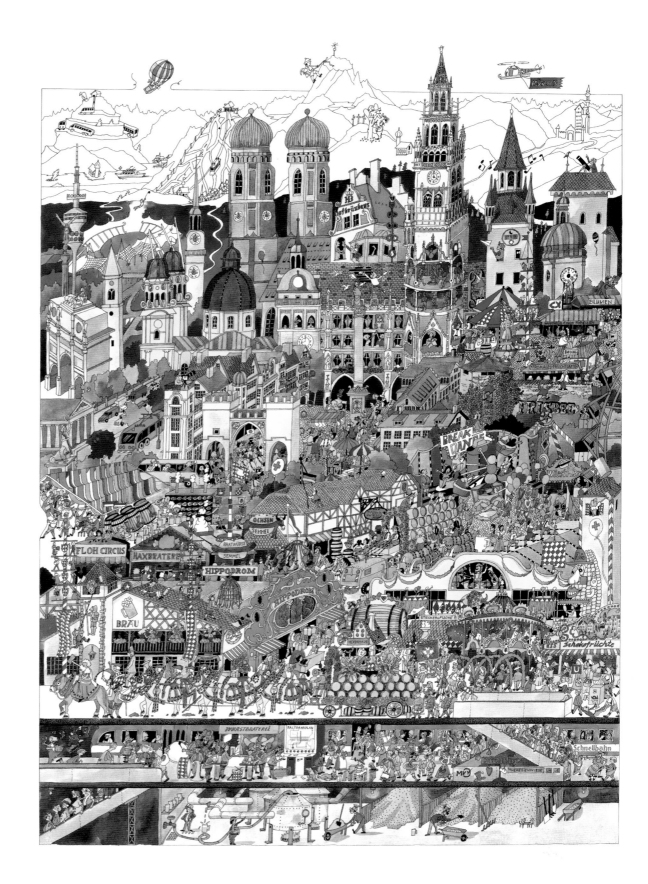

Munich Octoberfest (2001)

Whimsy

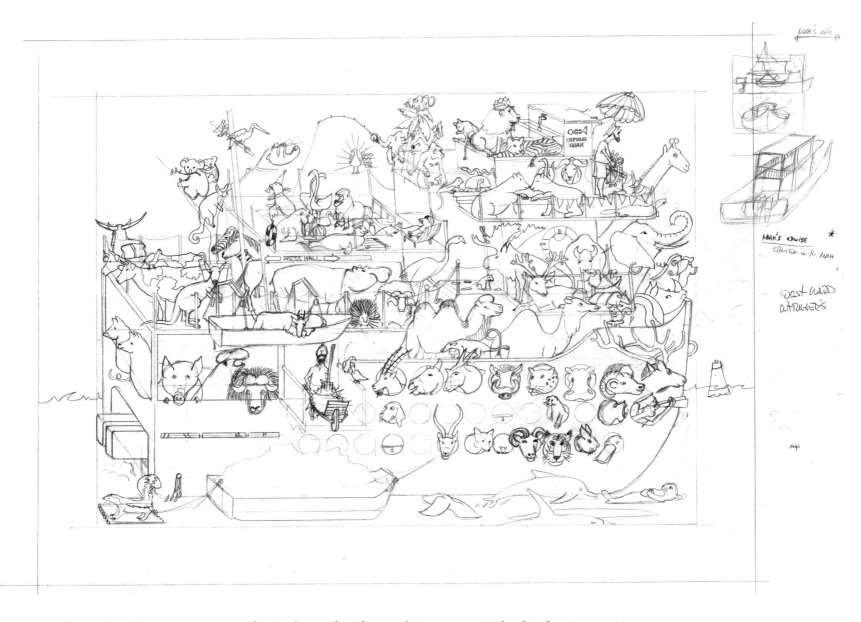

To make a drawing, I use a mechanical pencil with very thin 0.5mm HB lead. When I start, I usually have a general idea of what the finished drawing should look like. My initial ideas are sketched out on inexpensive bond paper because I know there will be many changes along the way. For complicated drawings I combine lots of these small sketches onto a large piece of tracing paper. When I'm satisfied with this large rough drawing, I put the tracing paper on a light table and trace the drawing onto a piece of 140-pound Arches hot-press watercolor paper. I then ink the drawing, adding fine details as I go. Of course, many times a new idea comes along at this point, which I can always find room for.

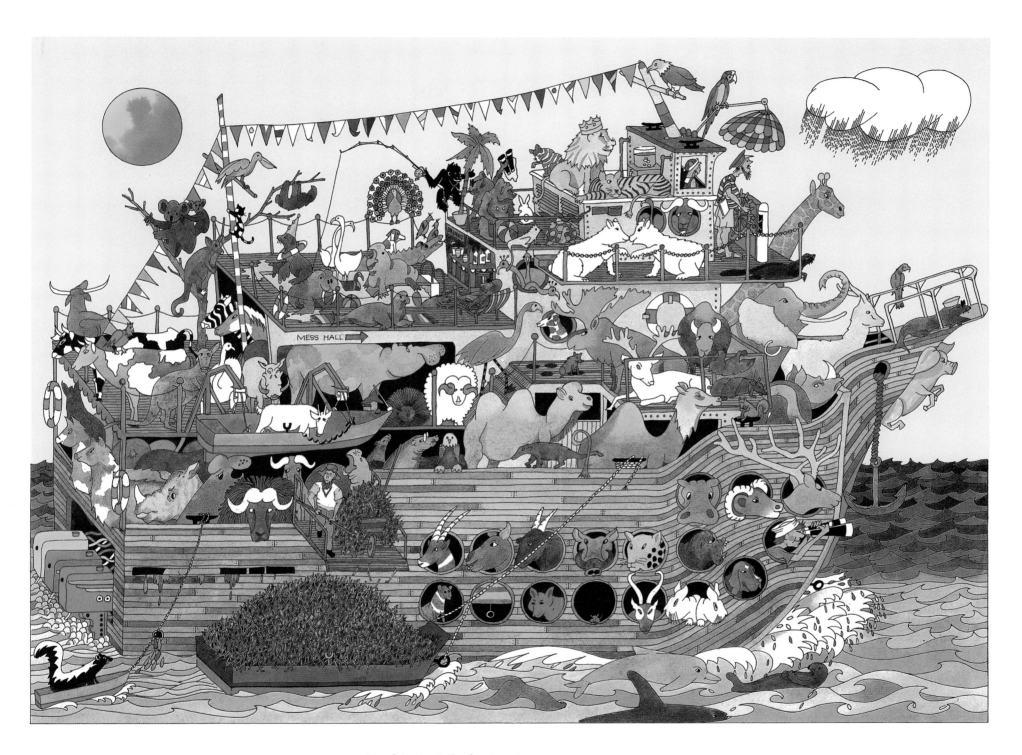

Noah's Next Cruise (1996)

I decided to update the story of Noah's voyage. One viewer told me this drawing was blasphemy. I've stayed away from religious themes ever since.

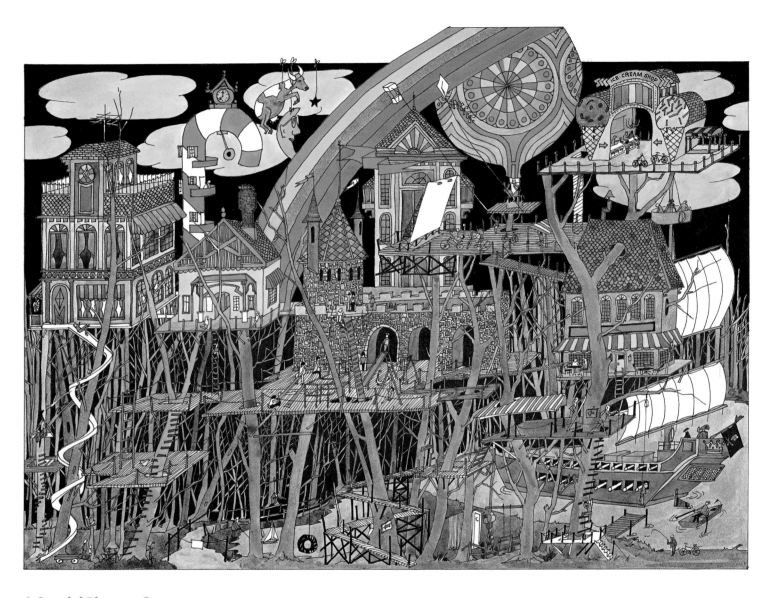

A Special Place to Go (1984)
As a kid I built a lot of tree houses and dreamed about all the wonderful things I wanted to put in
them. This is what I wanted but could never achieve in real life.

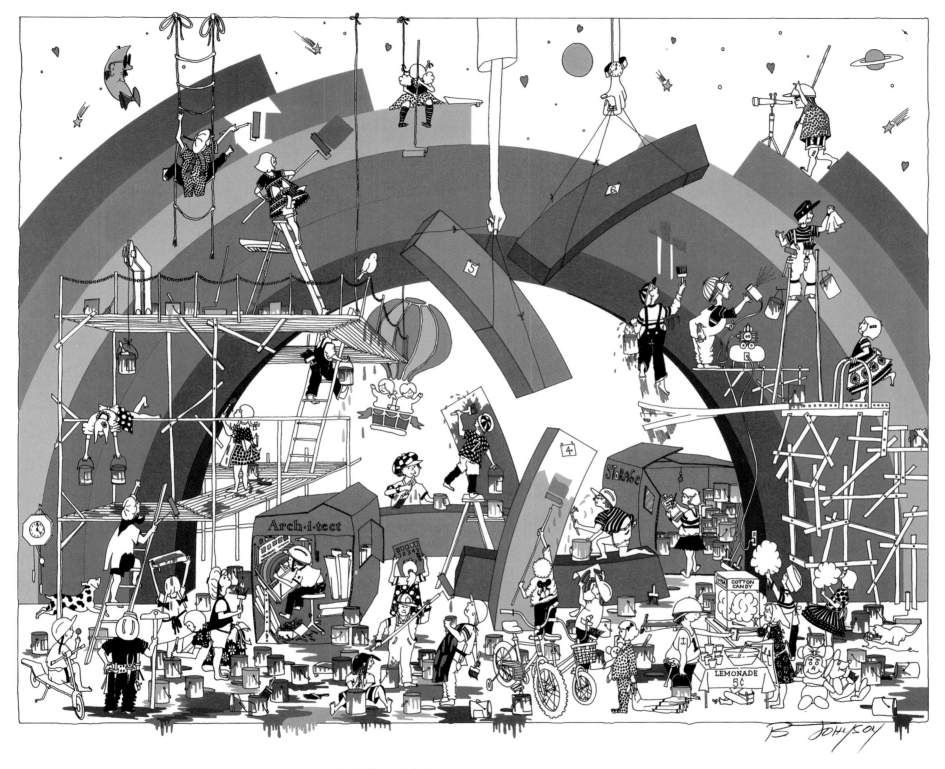

Building Rainbows (1989)
My way of saying that you can build your own future no matter how complicated it might seem.
You just have to do it. This piece was used by the Children's Miracle Network.

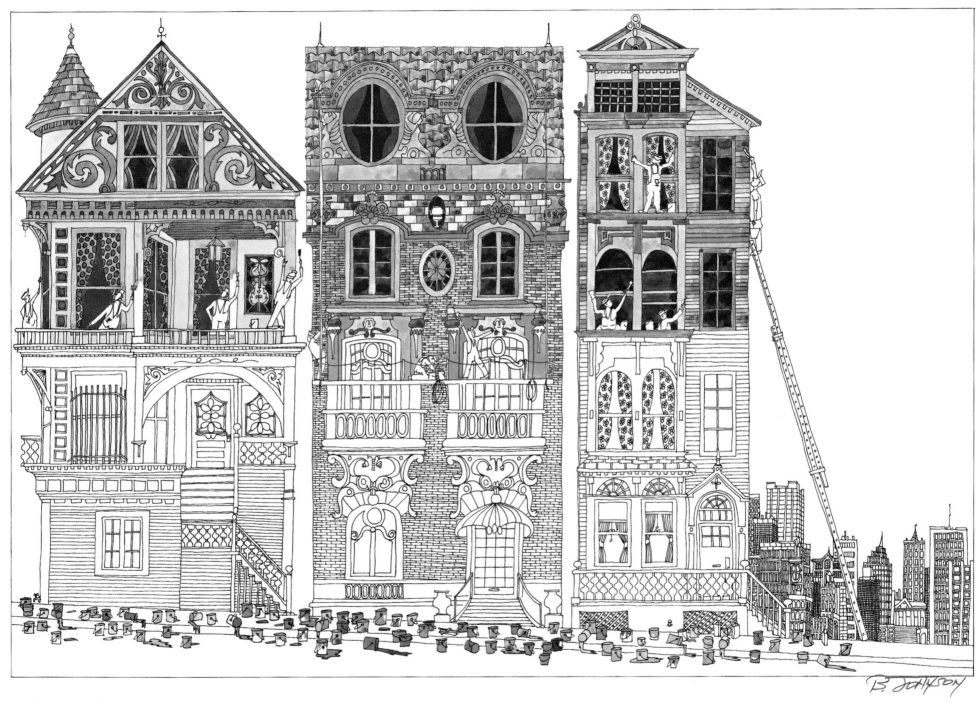

San Francisco (1983)

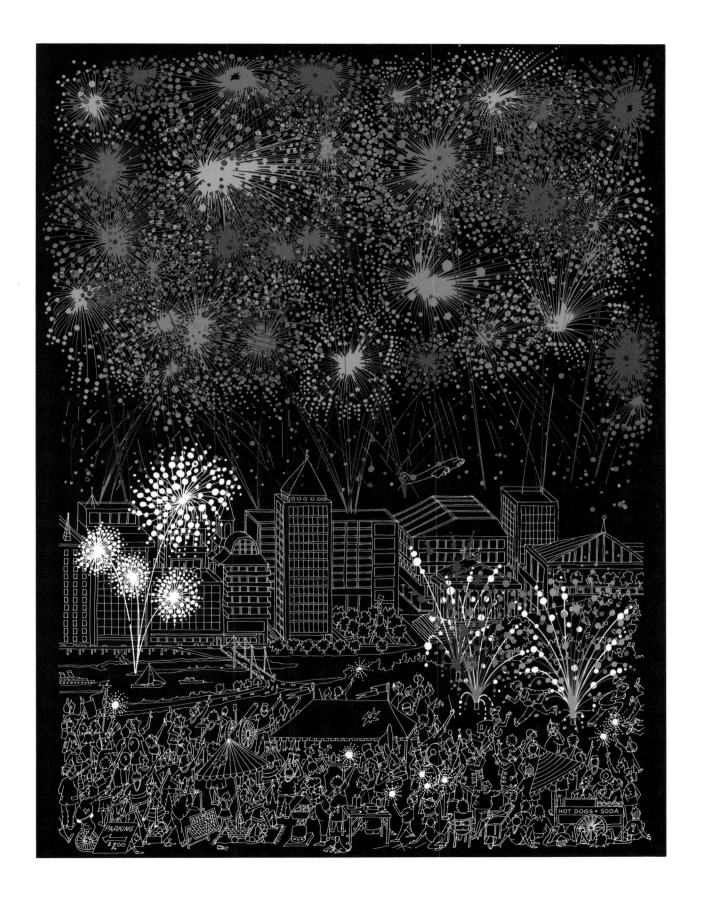

Grand Finale (1992)

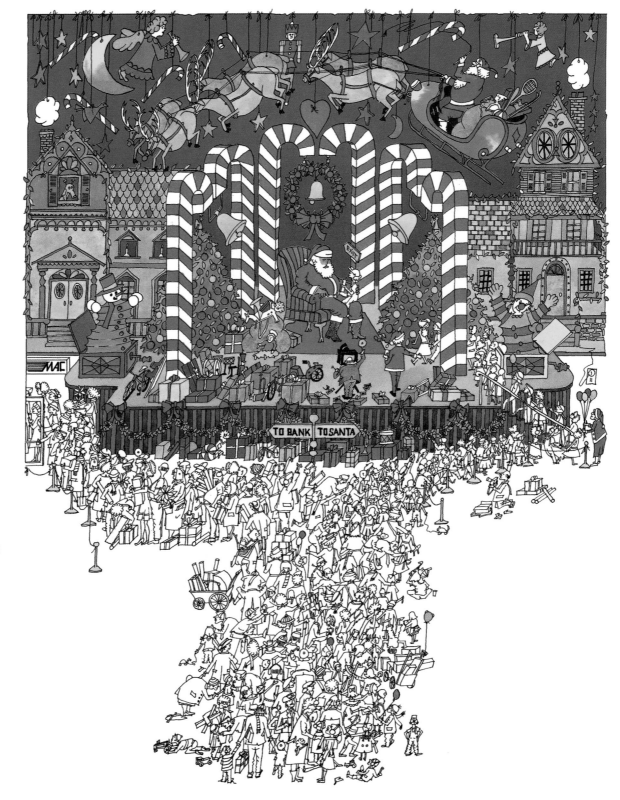

Ho Ho Ho (1992)

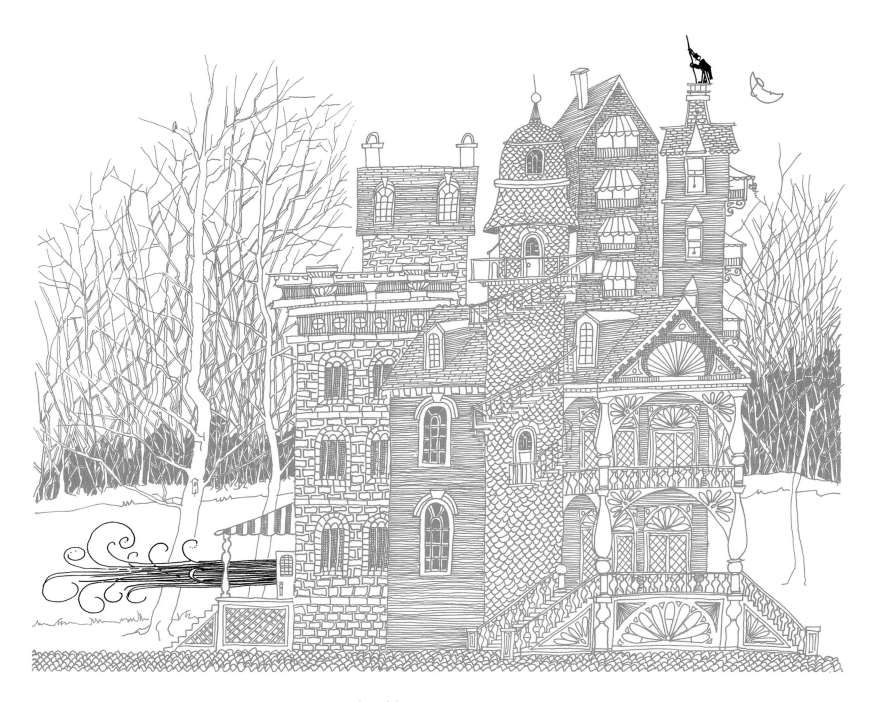

The Chimney Sweep (1981)
I once had the chimneys cleaned in our home and this vision appeared.

I Love a Parade (1999)
A trip to the Macy's Thanksgiving Day Parade in New York City inspired this drawing. My advice to anyone considering the same trip is to buy this print or watch the event on TV. Originally, I wanted to illustrate the actual balloon characters in the parade, but I soon realized I would then have to pay royalties to the creators of every balloon character. No thanks.

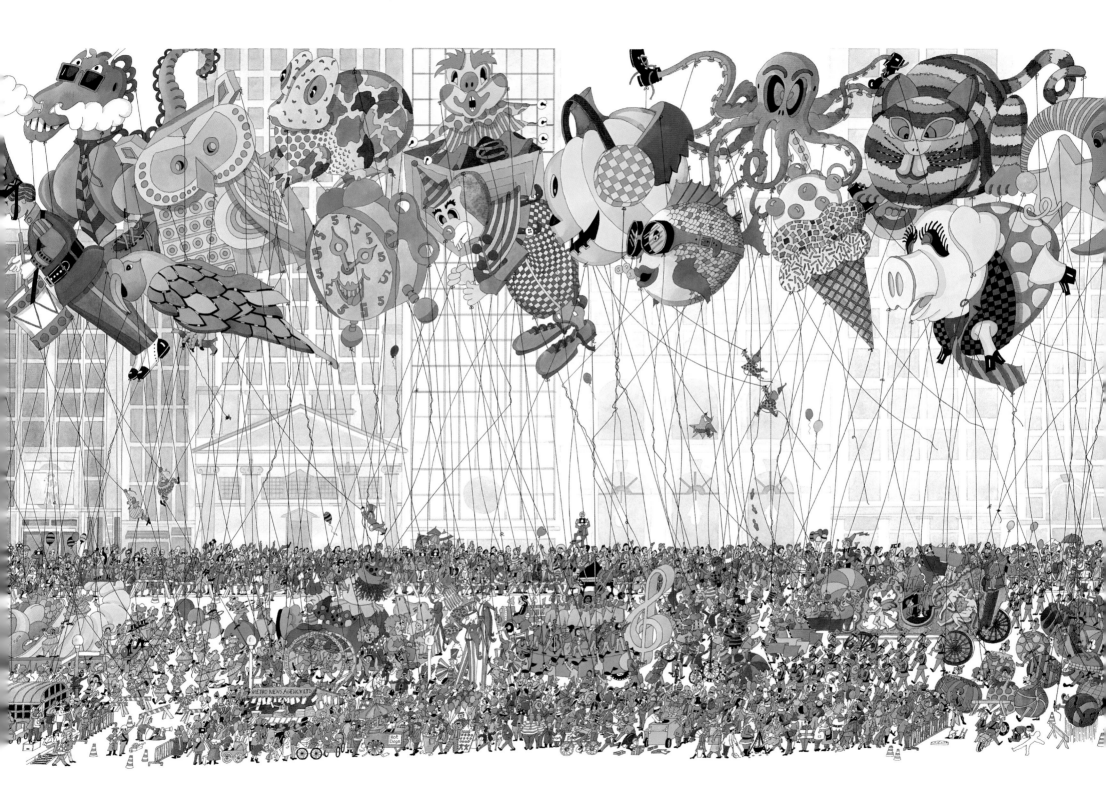

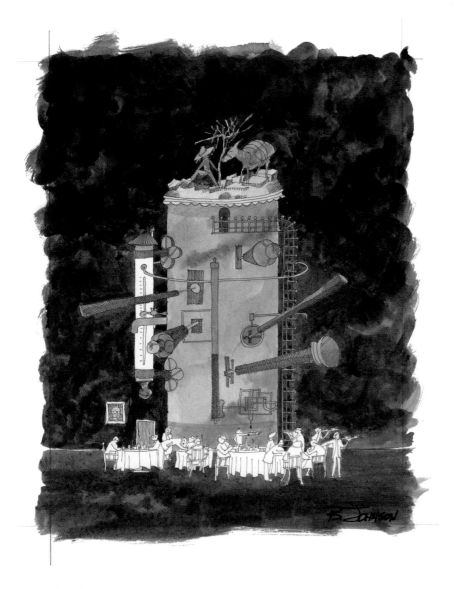

The Espresso Machine (1978)
I love the old espresso machines. I've always wanted to design a restaurant around a huge thirty-foot-high noisy machine with steam and all the bells and whistles.

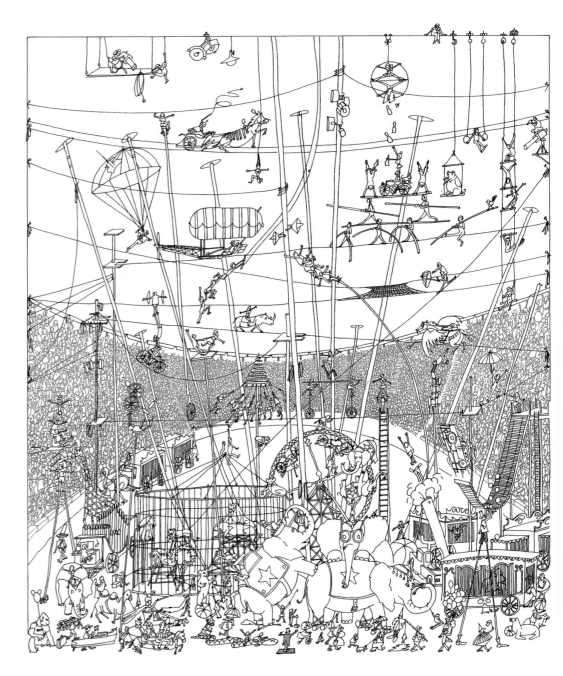

In the Center Ring (1982)
This is an attempt to illustrate the idea of control. Imagine the feeling of being the ringmaster, in complete control of everything that happens.

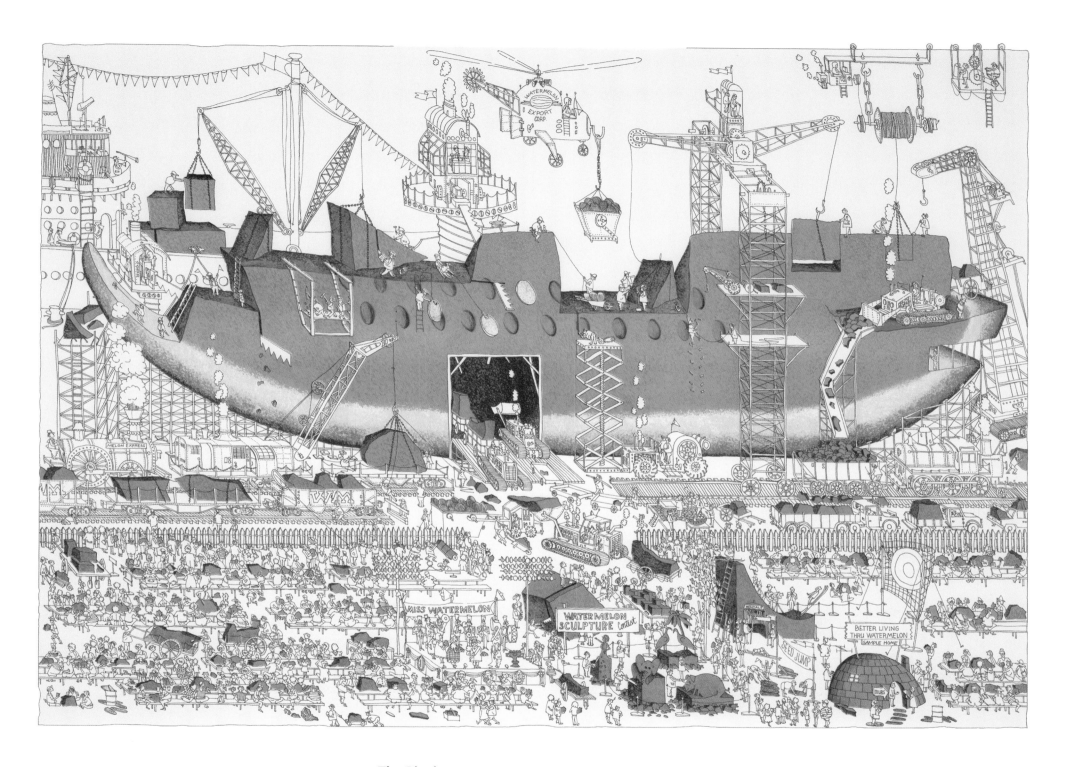

The Picnic (1985)
I personally do not like watermelon, but what a picnic this would be.

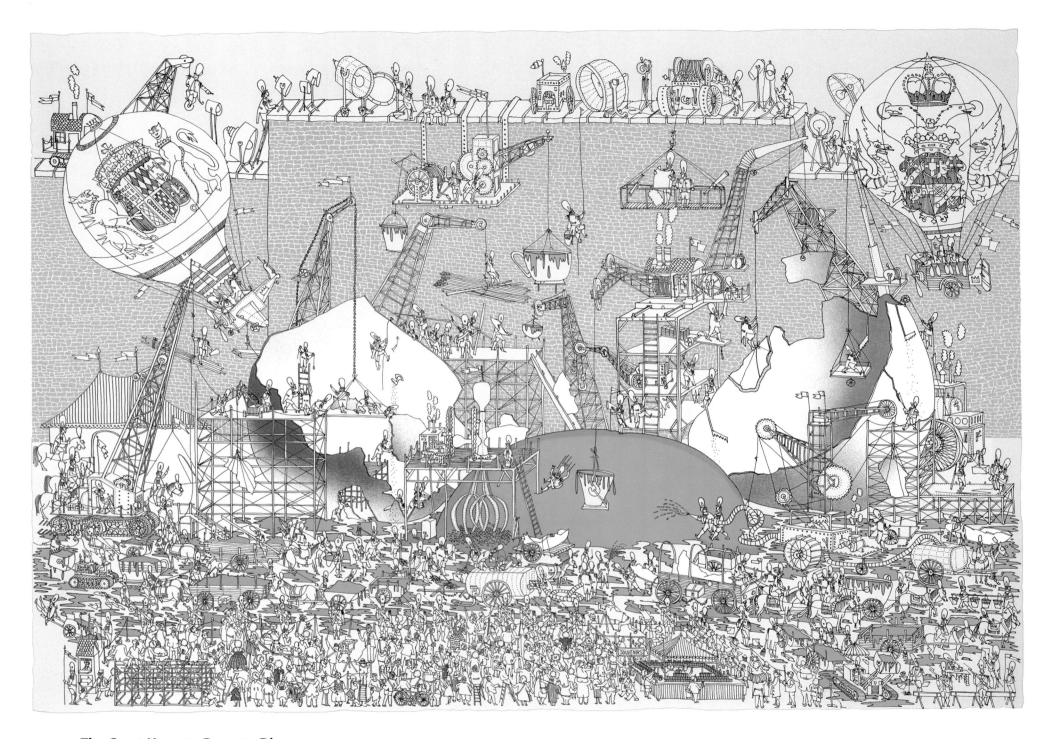

The Great Humpty Dumpty Disaster (1985)
I felt the story of Humpty Dumpty was never thoroughly researched. So I researched it and illustrated my findings.

Commercial Pieces

These drawings were all done for corporate clients. In most cases I used the same techniques I used for my other pieces and added a bit of whimsy to a place of business or a production process. These drawings are often more difficult than the others because I have to really understand what goes on at the place I'm illustrating. And I have to satisfy both myself and the company that's paying me to do the job. Many of these pieces were sold as limited-edition or open-edition prints and ended up on everything from T-shirts to coffee mugs. They were also used as employee gifts and in incentive programs. In general, they took a lot of time and research before I put pen to paper.

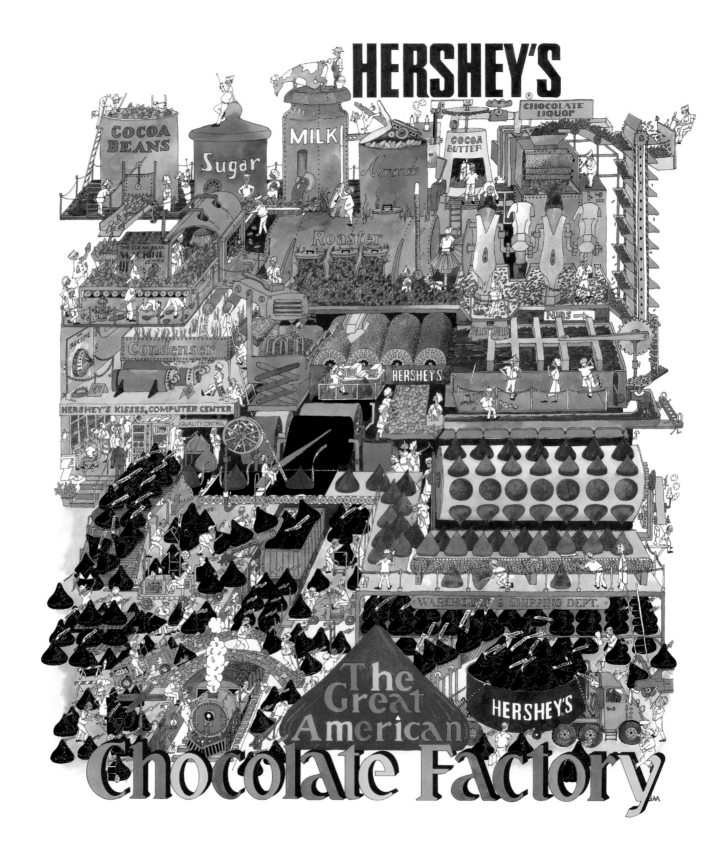

The Great American Chocolate Factory (1991)

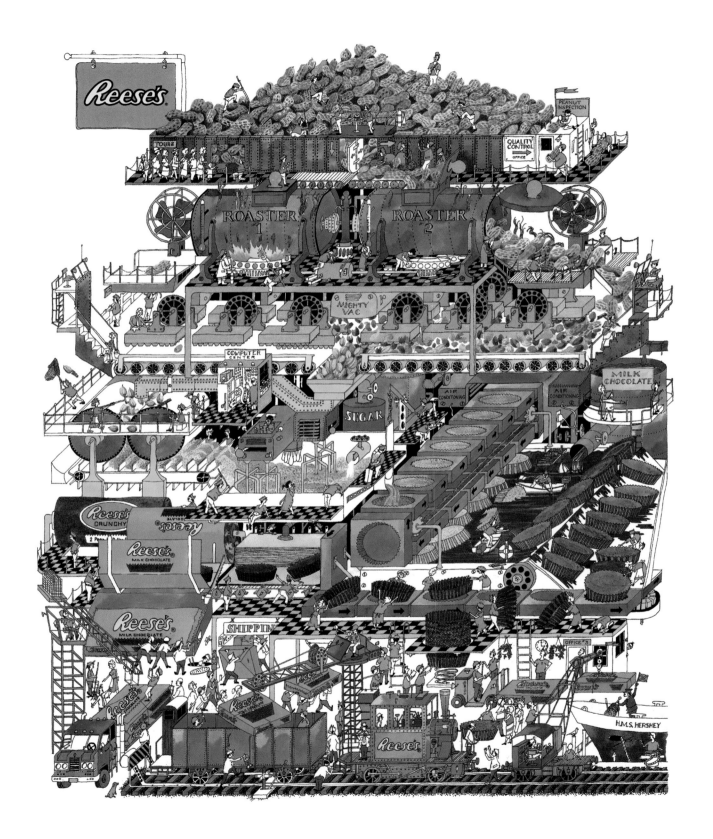

Reese's Factory (1993)

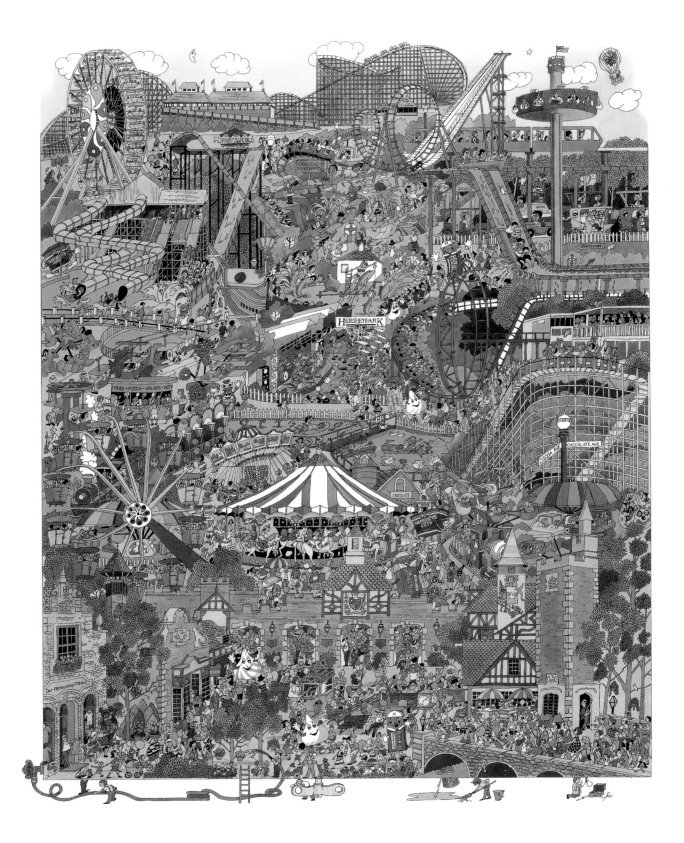

Hersheypark Happy (1996)

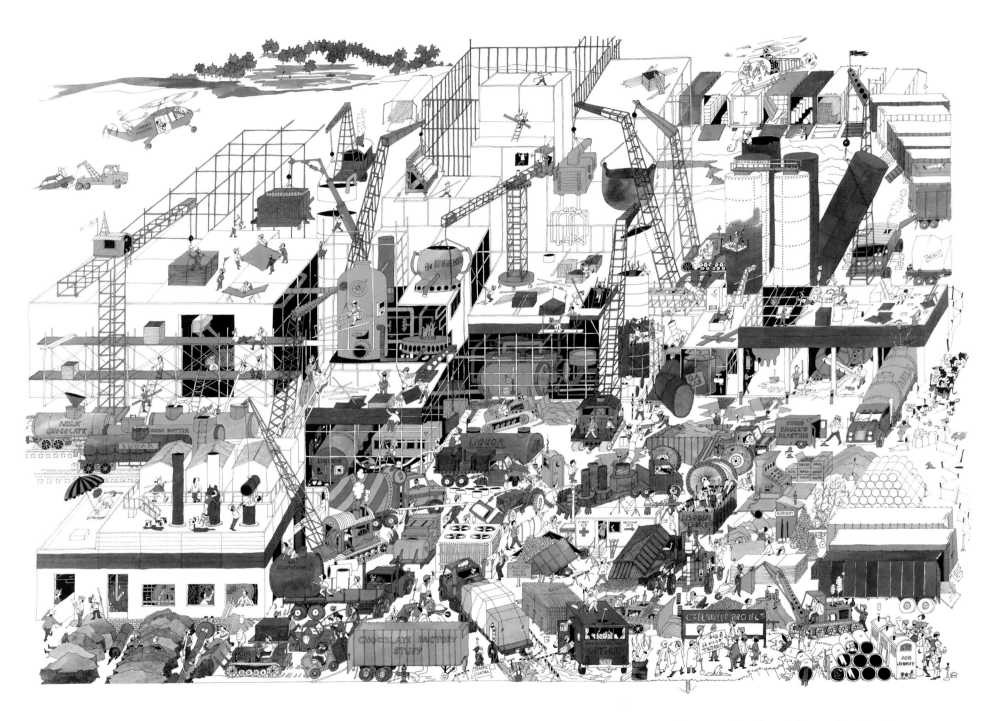

The New Hershey's Chocolate Factory (1995)

Stop and Smell the Roses (1997)

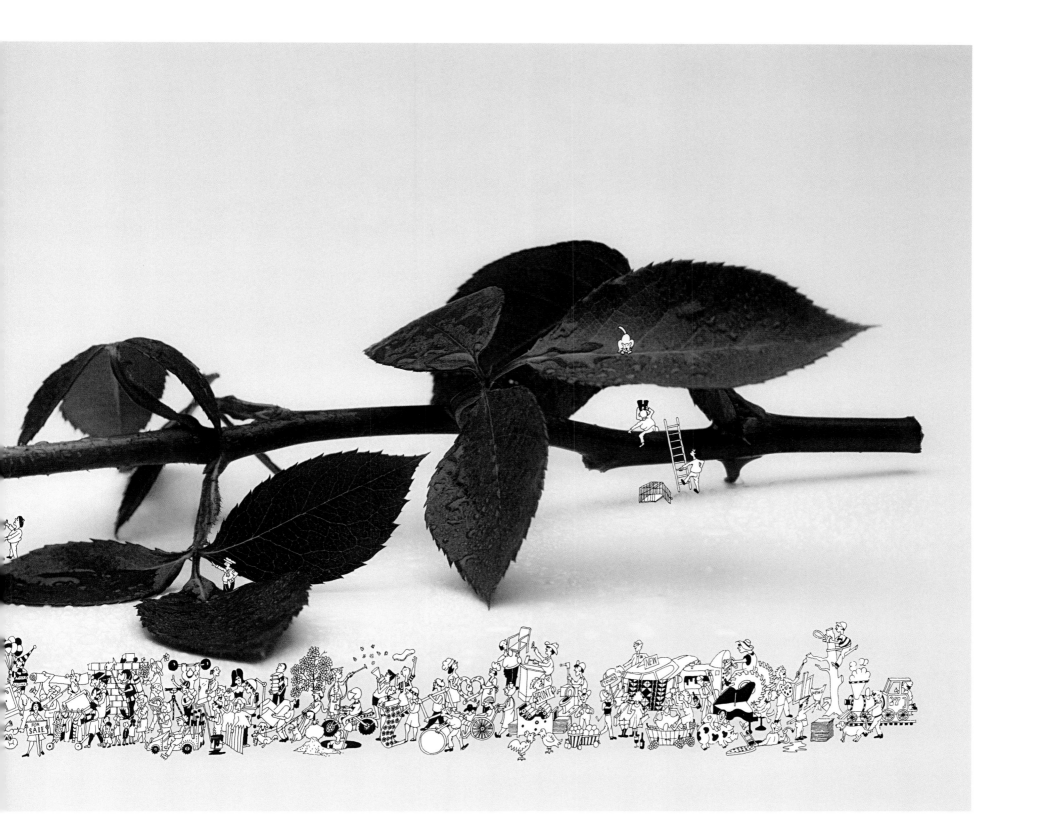

118

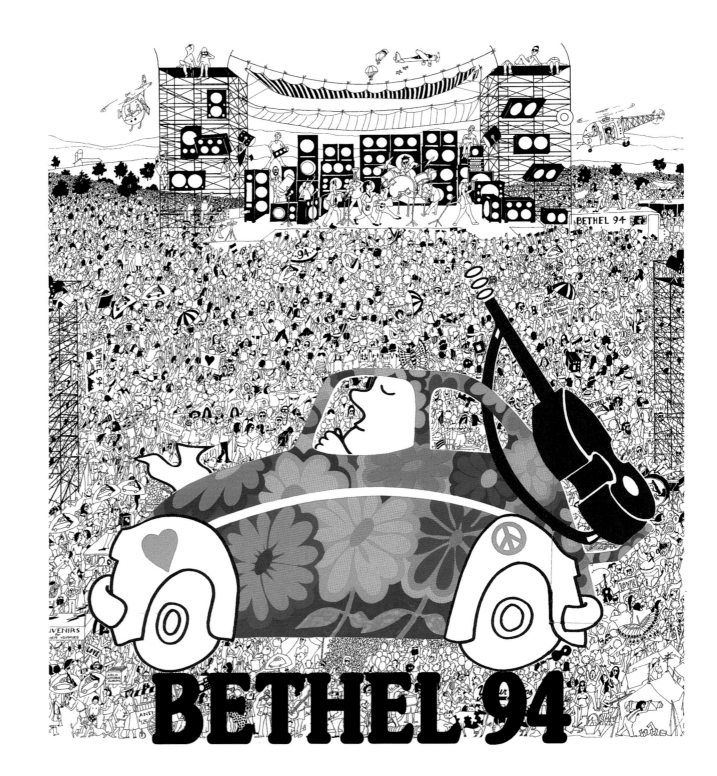

Bethel 94 (1994)

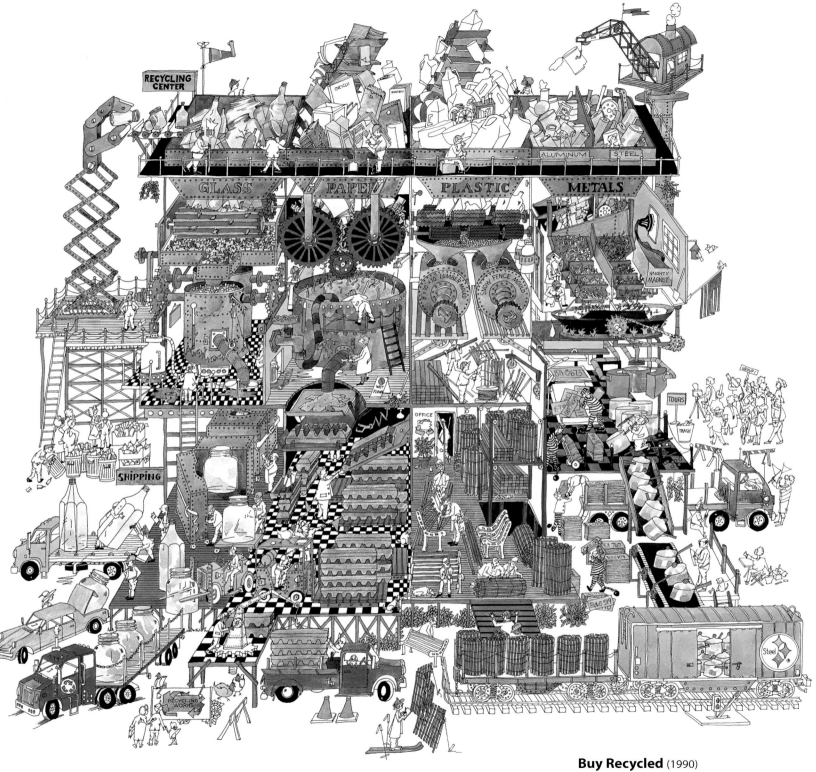

Buy Recycled (1990)

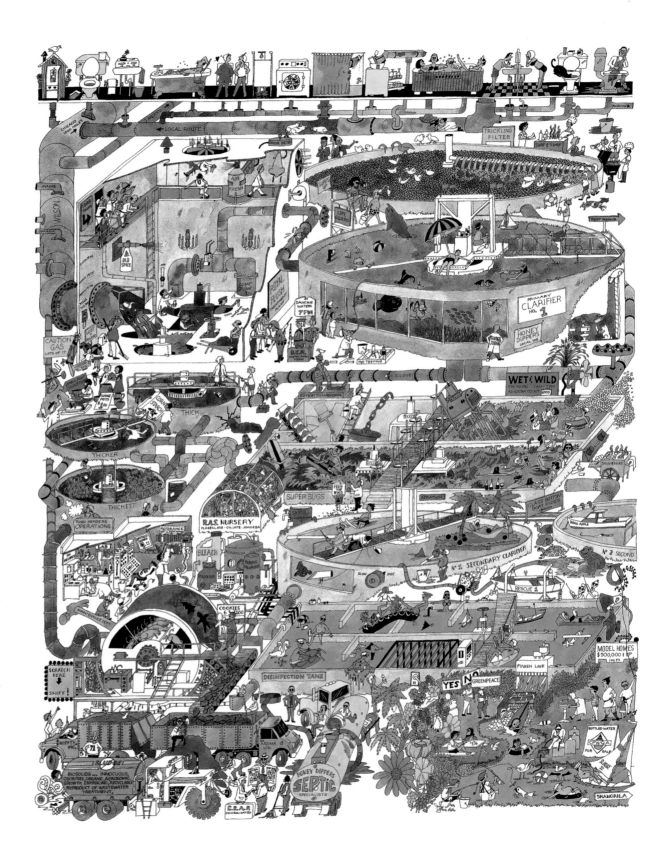

Go With the Flow (1994)

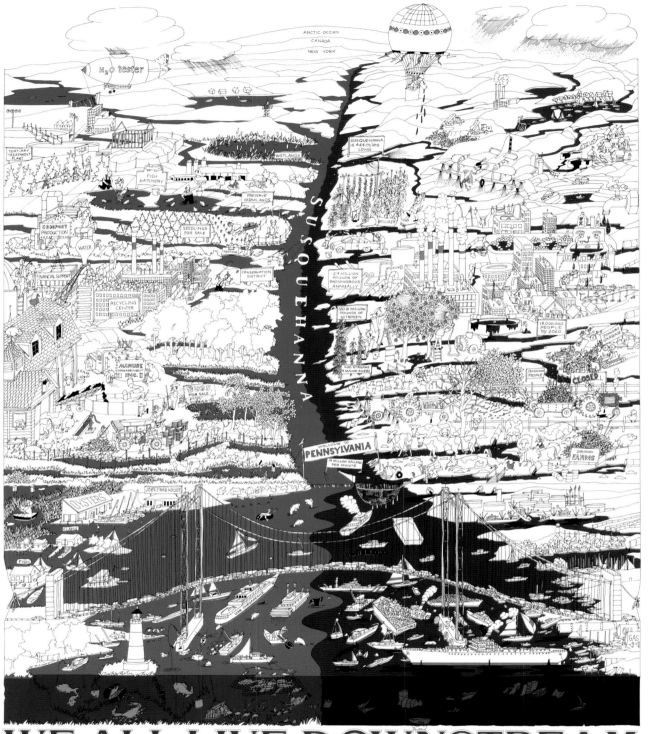

We All Live Downstream (1991)

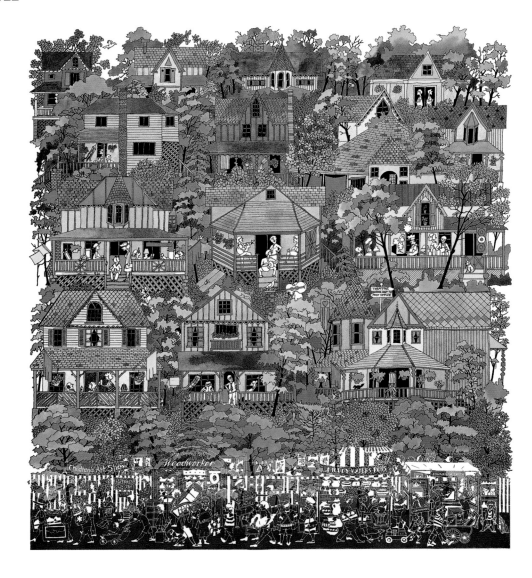

Under the Trees of Old Chautauqua (1992)

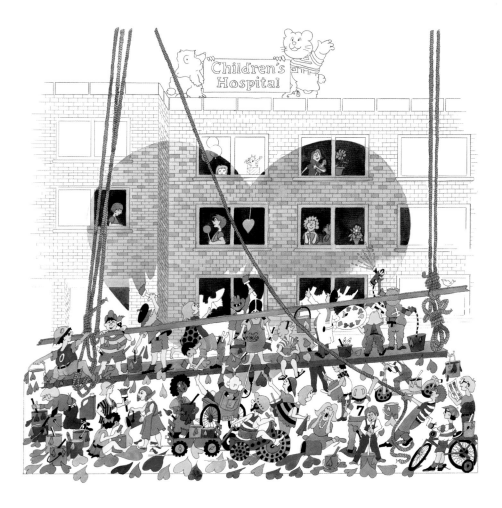

The House that Love Built (1996)

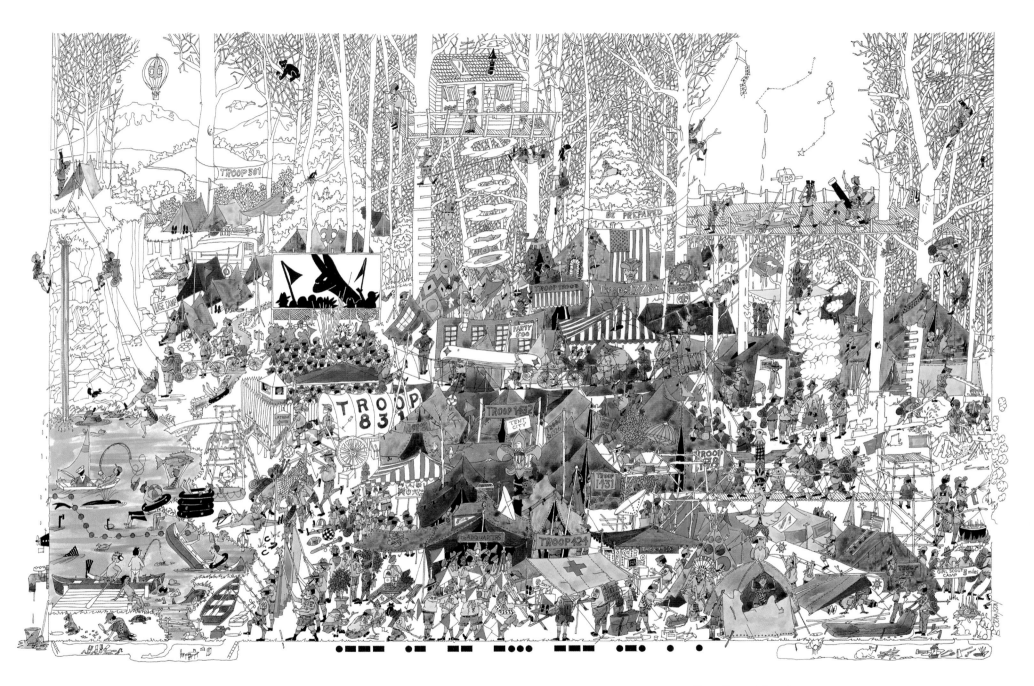

Boy Scout Jamboree (1990)

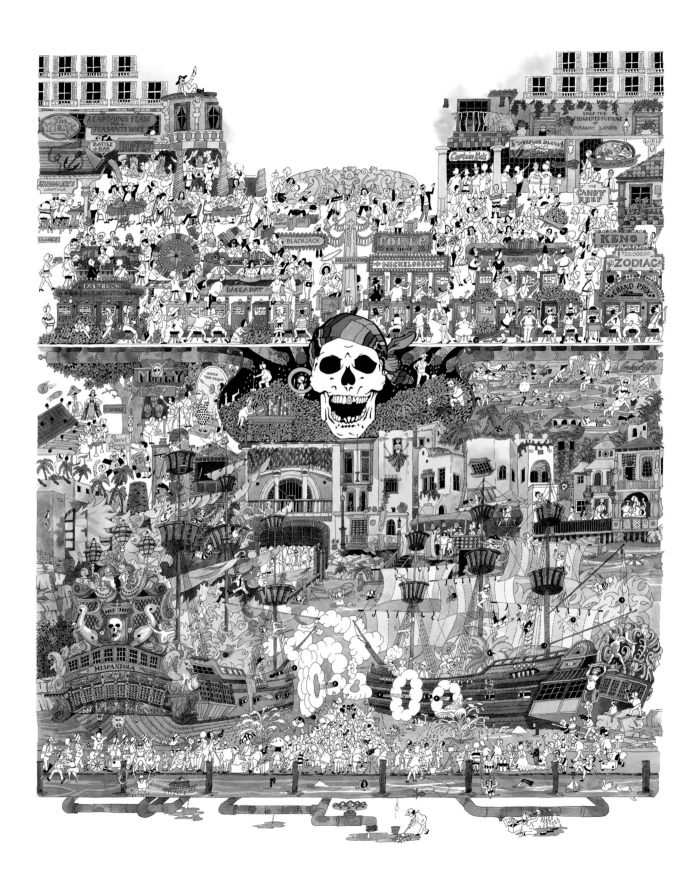

Treasure Island Casino (1993)

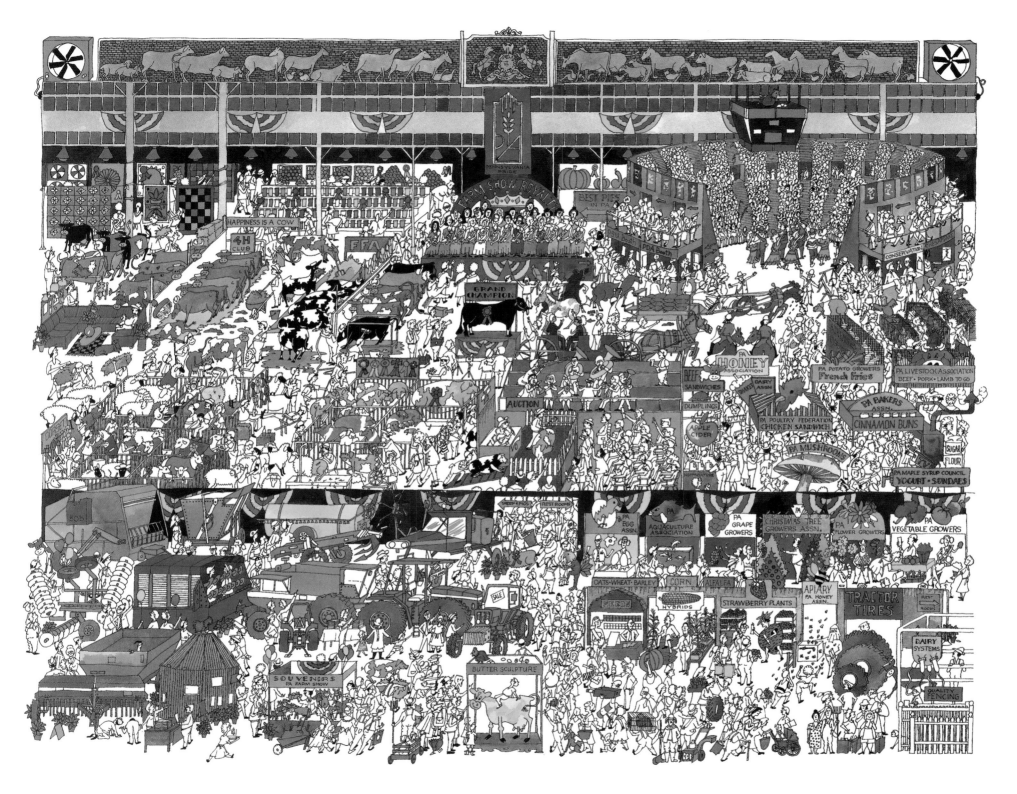

Pennsylvania Farm Show (1994)

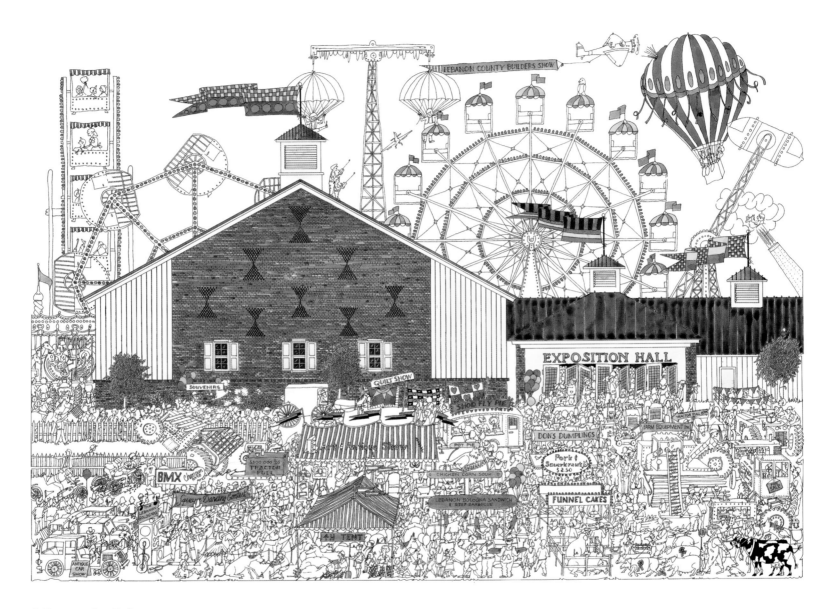

A Day at the Fair (1991)

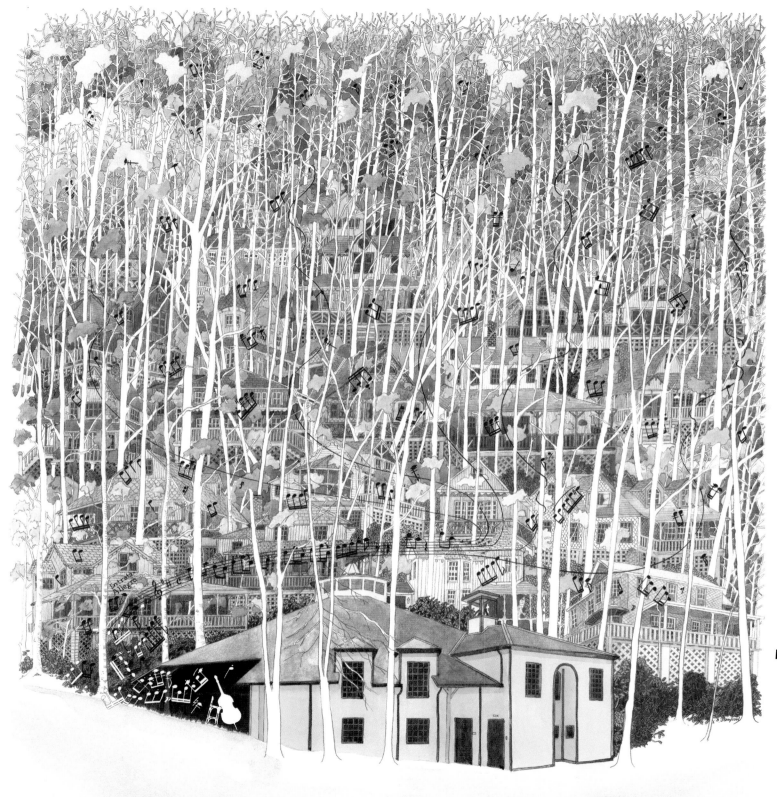

Mt. Gretna Playhouse (1998)

Exhibitions

SELECTED GROUP EXHIBITIONS

Art Association of Harrisburg, Harrisburg, PA, 1970–72

Margaret Lestz, Reed Dixon and Bruce Johnson, Marion Art Gallery, Lancaster, PA, 1970

American Watercolor Society, New York, NY, 1975

Annapolis Outdoor Art Show, Annapolis, MD, 1975

Atlantic City 15th Annual Art Show, Atlantic City, NJ, 1975

Lititz Outdoor Art Show, Lititz, PA, 1975–77

Mt. Gretna Chautauqua Art Show, Mt. Gretna, PA, 1975

Creative Artists, Pennsylvania Bicentennial Celebration, Harrisburg, PA, 1976

Juried Show, Allentown Art Museum, Allentown, PA, 1977

Bethlehem Outdoor Art Show, Bethlehem, PA, 1977

Doris Sams and Bruce Johnson, The William Ris Gallery of Camp Hill, Camp Hill, PA, 1978

Baltimore Watercolor Society, Baltimore, MD, 1981

American Watercolor Society, New York, NY, 1982

Woodmere Art Museum, Philadelphia, PA, 1982

National Watercolor Show, Los Angeles, CA, 1983

Art Expo, New York, NY, 1985–88

Atlanta Fine Arts Show, Atlanta, GA, 1985–88

Atlanta Watercolor Show, Atlanta, GA, 1985–89

Art Expo, Los Angeles, CA, 1987

Pennsylvania Society of Watercolor Painters, Philadelphia, PA, 1990

Philadelphia Watercolor Club, Philadelphia, PA, 1993

SELECTED SOLO SHOWS

Bruce Johnson, Gallatin National Bank, Harrisburg, PA, 1975

Bruce A. Johnson, Art Association of Harrisburg, Harrisburg, PA, 1976

Paintings of England and the British Isles, Gallery 444, Annville, PA, 1980

Germany and Austria, Gallery 444, Annville, PA, 1981

Bruce Johnson, Good Samaritan Hospital, Lebanon, PA, 1982

Paintings of Holland, Gallery 444, Annville, PA, 1982

Faces of China, Gallery 444, Annville, PA, 1984

Painting China—Bruce Johnson AWS, William Ris Gallery, Stone Harbor, NJ, 1984

Christmas Show, Gallery 444, Annville, PA, 1984

Yugoslavia, Gallery 444, Annville, PA, 1985

Provence, Gallery 444, Annville, PA, 1986

Creative Source Market Show, Doshi Center for Contemporary Art, Penn Harris Inn and Convention Center, Camp Hill, PA, 1986

Bruce Johnson, Hershey Medical Center, Hershey, PA, 1986

A Portrait of Russia, Gallery 444 at Chimneys, Hershey, PA, 1988

The Art of Great Britain, Ladd-Hanford Jaguar, Hershey, PA, 1990

In My Own Backyard, Gallery 444 at Chimneys, Hershey, PA, 1992

Bruce Johnson, Gallery New York, Brugg, Switzerland, 1992

Bruce Johnson's Statements, Home Fair of QVC Home Shopping Network, 1992

Bruce Johnson, Globus, Basel, Switzerland, 1993

———, Swiss ATP International Tennis Tournament, Basel, Switzerland, 1993

———, Galerie Nievergelt, Zurich, Switzerland, 1993

———, Galerie Martgass, Rapperswil, Switzerland, 1993

Switzerland: Where the Mountains Meet the Heavens, Gallery 444
 at Chimneys, Hershey, PA, 1994
Bruce Johnson, Caveing 3-D Galerie, Arosa, Switzerland, 1994
———, Ambiente International Frankfurter Meese, Frankfurt,
 Germany, 1994
———, Galerie Graf, Hombrechtikon, Switzerland, 1994
———, Galerie Ideereal, Adliswil, Switzerland, 1994
———, Globus Wohnen, Basel, Switzerland, 1995
———, Werkstatt Galerie, Zurich, Switzerland, 1995
———, Galerie Rachel, Frankfurt, Germany, 1995
———, Galerie Springmann, Freiburg, Germany, 1995
———, Altersheim Bachgraben, Allschwil, Switzerland, 1995
3-D Statements, Hotel Kempinski, Frankfurt, Germany, 1995
Bruce Johnson: Antipasto and Irish Stew, Gallery 444 at Chimneys,
 Hershey, PA, 1996
Bruce Johnson, Novotel Mannheim, Mannheim, Germany, 1996
———, Ambiente International Frankfurter Messe, Frankfurt,
 Germany, 1996
———, Galerie Santis, Gossau, Switzerland, 1996
———, Buk, Basel, Switzerland, 1996
———, Universitatsklinik, Basel, Switzerland, 1996
———, Rahme-Laden, Winterthur, Switzerland, 1996
———, Rahmenatelier Martgass, Rapperswil, Switzerland, 1996
———, Kulturelles Gebaude Aschheim, Aschheim, Germany, 1996
———, Kunsthandlung Springmann, Freiburg, Germany,
 1997–2000
A Thin Line—A Broad Brush: The Art of Bruce Johnson, Susquehanna
 Art Museum, Harrisburg, PA, 2002

To see more of Bruce Johnson's
artwork, or to order prints, visit
www.bjohnsonltd.com

Index of Artwork